IMAGES of America
HADDONFIELD

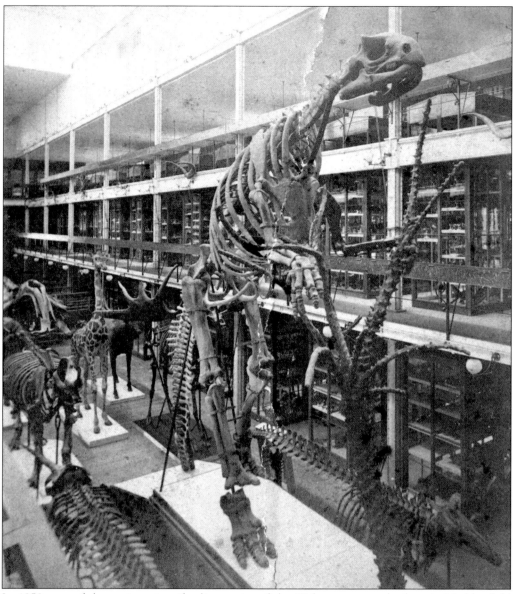

In 1858, one of the major scientific discoveries of the 19th century took place in Haddonfield when William Parker Foulke visited Birdwood, the home of John Estaugh Hopkins, and saw a dinosaur bone being used as an umbrella stand. Foulke received permission to dig for more specimens in the marl bed where the bones had been found 20 years earlier. Foulke sent word to the Academy of Natural Sciences asking Dr. Joseph Leidy to come to Haddonfield to examine his find. They were rewarded with the first nearly intact dinosaur skeleton found anywhere in the world. As a result of his studies, Leidy correctly deduced that the dinosaur stood on two legs rather than four and, in 1868, had the specimen mounted for display at the Academy of Natural Sciences, as seen in this photograph. (Courtesy of the Academy of Natural Sciences, Ewell Sale Stewart Library.)

On the cover: Please see page 53. (Courtesy of the Historical Society of Haddonfield.)

Katherine Mansfield Tassini
and Douglas B. Rauschenberger
with the Historical Society of Haddonfield

Copyright © 2008 by Katherine Mansfield Tassini and Douglas B. Rauschenberger with the Historical Society of Haddonfield
ISBN 978-0-7385-5674-1

Published by Arcadia Publishing
Charleston SC, Chicago IL, Portsmouth NH, San Francisco CA

Printed in the United States of America

Library of Congress Catalog Card Number: 2007943908

For all general information contact Arcadia Publishing at:
Telephone 843-853-2070
Fax 843-853-0044
E-mail sales@arcadiapublishing.com
For customer service and orders:
Toll-Free 1-888-313-2665

Visit us on the Internet at www.arcadiapublishing.com

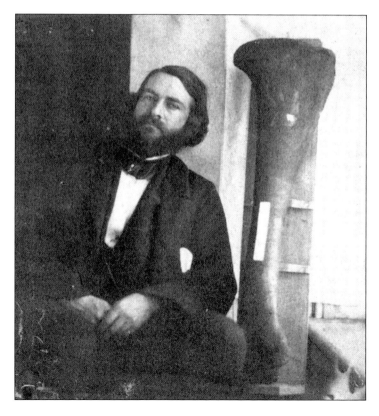

Dr. Joseph Leidy is seated next to a Hadrosaurus foulkii bone found in Haddonfield in 1858. (Courtesy of the Academy of Natural Sciences, Ewell Sale Stewart Library.)

CONTENTS

Acknowledgments		6
Introduction		7
1.	Transportation	9
2.	Businesses	23
3.	Community Services	45
4.	Churches	59
5.	Schools	69
6.	Houses and Street Scenes	79
7.	People and Lifestyles	101
Index		126

ACKNOWLEDGMENTS

Since its founding in 1914, a major focus of the Historical Society of Haddonfield has been its collection of primary source materials, including photographs that relate to Haddonfield and the vicinity. The early commitment of the founders of the society to collect and document the history of the town has continued with great dedication through the nearly 100-year history of the organization. The result of its vision is a rich and deep library collection from which we were able to select the majority of the images used in this publication.

Unless otherwise credited, the images in this publication are from the society's collection. Within that collection, photographs donated by the Wood family; Betty and Robert Rhoads; the Allen family; the Moore, Tatem, and Brigham families; Mary Bauer; Rachel Heston; Elizabeth Lyons; and the estates of Helen Kulp, James Stretch, Lawrence R. and Elizabeth Willard Andress; and Josephine Wallworth Bentley were used extensively. Also meriting special mention is the photographic collection donated by William Searle, editor of the *Haddonfield Herald*, later the *Town Crier and Herald* newspaper. This was an invaluable source of images from the late 1940s through the early 1960s.

The society's partner in local history, the Haddonfield Public Library, supplied a substantial number of photographs. Other institutions and government agencies providing images include the Borough of Haddonfield, the Haddonfield Police Department, Haddon Fire Company No. 1, the Haddonfield United Methodist Church, Lutheran Church of Our Savior, Bancroft NeuroHealth, and Ewell Sale Stewart Library at the Academy of Natural Sciences.

Many individuals and families also generously allowed the historical society to use photographs from their personal collections. Our thanks goes to Mary Jane Freedley, Robert T. Henry, Parker Griffeth, Joyce Hillman Hill, Dr. Edward J. Huth, Dianne Hartel Snodgrass, Louis Goddard and the estate of William Cope, Helen Stiles Peterson, Linda and Butch Brees, Hoag Levins, Helen Stevens Mountney, Don Harris, and Tom Tomlin for their contributions. Finally, a special thank-you goes to Anne and Boyd Hitchner, from whose extensive collection of Haddonfield postcards and photographs we have used so many wonderful, unique images. The publication is all the richer for the generosity of all these contributors.

INTRODUCTION

Over the 300 years since the area known today as Haddonfield was first settled, most historians have concluded that some sort of settlement would inevitably have been established within a mile of the present town. The reason then, as now, was location. Haddonfield was located halfway between the two major Quaker settlements of Burlington and Salem at a point where Cooper's Creek could both be crossed at most times of the year and where boats carrying goods could still navigate and be off-loaded.

The early establishment and predominance of Haddonfield came as the result of the 1701 arrival in the area of Elizabeth Haddon, a young Quaker woman who came to claim lands bought by her father, John Haddon, a prominent London Quaker, anchor smith, and mining expert.

John had been purchasing land in the Delaware valley since the late 17th century. It was his intention to bring his family to the New World where they would find the freedom to practice their religion in peace and allow the same freedom of religion to others. Among the lands he purchased were 450 acres that were bounded by Kings Highway and Cooper's Creek. It was this land that became New Haddonfield Plantation in 1713 and formed the basis for the evolution of a community along Kings Highway at this location.

Although Francis Collins had settled 500 acres on the south side of Kings Highway in 1682 and built an impressive brick home called Mountwell on his land, Collins did nothing to encourage others to settle in the vicinity. After the arrival of Elizabeth and her husband, John Estaugh, a Quaker minister whom she married in 1702, settlement along Kings Highway was encouraged by their willingness to sell or rent smaller lots of land to the blacksmiths, tanners, tavern keepers, saddlers, and other men working in trades necessary to support the establishment of a community. Because of its central location, Haddonfield became the local hub where farmers in the areas surrounding the town came for necessary supplies and repairs.

The importance of Haddonfield was further bolstered when, in 1721, Elizabeth brought a deed from her father in England for an acre of land near the main intersection in town to be used for a Friends meetinghouse and burying ground. Prior to this gift, the Quakers, who predominated in the area, met alternate weeks at Newton Meetinghouse on Newton Creek in what is now West Collingswood and at the house of Thomas Shackle, which was located on Kings Highway in what is now Cherry Hill. The establishment of Haddonfield Friends Meeting in 1721 made the fledgling community the commercial, social, and religious hub of the area.

From the early 18th century to the middle of the 19th century, Haddonfield was a central player in the history of the region. It was where the farmers and their families who lived in the surrounding areas came for trade, worship, and social interaction. Goods going to market in

Philadelphia from "down Jersey" inevitably passed through Haddonfield because of the early road system. During the American Revolution, both British and American troops also passed through the town because of its central location. Among significant revolutionary events were the meeting of the New Jersey legislature in the Indian King Tavern, the run of the youthful Jonas Cattell from Haddonfield to Red Bank to warn of an attack by the British, and the holding of Tory trials at the Indian King Tavern.

Following the American Revolution, the town continued as a commercial, social, and religious center. In 1764, a volunteer fire company was formed, the second-oldest continually active one in the country. The late 18th and early 19th centuries also saw the establishment of a Friends school, a library, and an early precursor to the public school system. Town meetings for Newton Township, the governing body for the region, were regularly held at either the Friends meetinghouse or Friends school in Haddonfield.

The character of the town began a major change in 1853 with the coming of the Camden and Atlantic Railroad from Philadelphia to Atlantic City. Initially the railroad made Haddonfield a summer retreat from Philadelphia. During this era, one of the most important discoveries relating to the town occurred. In 1858, William Parker Foulke, a lawyer and amateur naturalist from Philadelphia, was visiting Haddonfield and was invited to dinner at Birdwood, the home of John Estaugh Hopkins, a descendant of Elizabeth Haddon Estaugh. At Birdwood, Foulke observed a large fossil bone being used as an umbrella stand. Upon learning that it was one of several bones found in an old marl pit on the Birdwood property many years earlier, Foulke and his mentor, Dr. Joseph Leidy, obtained permission to reopen the marl pit to look for more bones. The result was the discovery of the first nearly intact dinosaur ever found anywhere in the world. It was named Hadrosaurus foulkii, and it changed forever the scientific understanding of dinosaurs.

During the late 19th century as the railroad expanded and the Victorian era progressed, Haddonfield saw its first housing developments. The farms closest to the center of town were sold to land companies, and lovely Victorian homes were erected on spacious lots. The town continued its development as a railroad suburb at a genteel pace until the 1920s when the Delaware River Bridge (today known as the Benjamin Franklin Bridge) opened. The bridge and the growing importance of cars led to the town's new wave of development as an automobile suburb.

In the 1940s, the Haddonfield Civic Association encouraged business owners to adopt a Colonial appearance for their shops, which greatly improved the appearance of the downtown area. Late in the 1960s with the coming of the high-speed rail line to Philadelphia, the community faced a crisis created by developers who were anxious to tear down much of the historic fabric of the town and erect modern office complexes. The community responded with a historic district ordinance, which was established by referendum in 1971. This ordinance protected the historic core of the town from demolition and has resulted in the historic appearance for which the town is widely known today.

Haddonfield at the beginning of the 21st century is a successful, residential community with historic homes, excellent schools, lovely shops and restaurants, and historic sites. The community has been fortunate in its long history to have residents who value the character, history, and continuity of the town. The images that we are fortunate to be able to present in this publication are available because of the establishment of the Historical Society of Haddonfield in 1914. As the result of a huge celebration in 1913 of the 200th anniversary of the settlement of Haddonfield, residents realized that there were many important documents, images, and artifacts relating to the community that should be preserved and made available for future generations. Today the Historical Society of Haddonfield continues to collect, organize, and share these important materials with a wide variety of constituencies from local school children to national media outlets. It is our hope that these images from the late 19th century to the late 20th century will awaken memories and the sharing of stories for those who remember the people, places, and occasions in this book, and that it will serve as a source of interest and insight for future generations.

One
TRANSPORTATION

Throughout its long history, transportation patterns have been a key to the success and development of Haddonfield. In the late 1600s and the 1700s, the most important means of transportation was the navigable tidal waters near the town. More importantly, these waters linked Haddonfield with nearby Philadelphia, the largest Colonial city and a thriving international port. Haddonfield was along the earliest road through what was then West Jersey. Kings Highway was laid out in the 1680s and stretched from the then large settlements of Burlington to the north and Salem to the south and ran through what became the village of Haddonfield. Other early roads soon followed and linked the interior of West Jersey with the developing town. The expanding road system in the late 18th and early 19th centuries also brought the first form of public transportation, stagecoach service, connecting Haddonfield first with Camden and later with other towns.

The arrival of the railroad in 1853 immediately began to transform Haddonfield from a small agricultural village to a growing suburb. Long a regional center for business and commerce, for a time the railroad greatly expanded Haddonfield's role as a business center. The addition of the trolley in 1895 provided one more method of public transportation to the bustling town.

The automobile eventually assured the end of Haddonfield's agricultural past as well as the end of the trolley. By the mid-20th century, Haddonfield had become a fully developed suburban community. The suburbanization was further solidified when the slower passenger railroad service was replaced in 1969 by high-speed rail transportation, which has become an integral part of the fabric of life in Haddonfield.

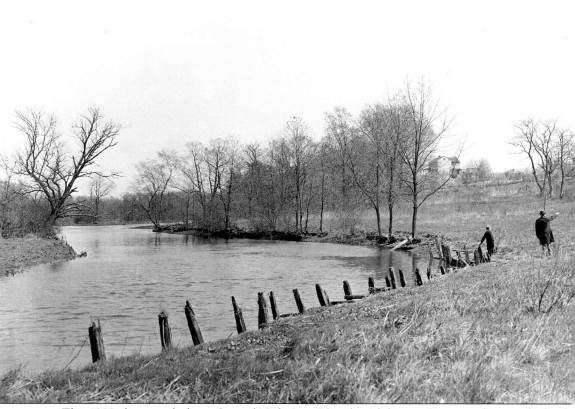

This 1909 photograph shows Samuel Nicholson Rhoads with his son Evan standing on the bank of Cooper's Creek near present-day Grove Street. In Colonial times, water transportation was the main means of moving goods. This site was as far as one could flat a boat, and it was still tidal water, which allowed natural forces to help move the boats up and down the creek. Haddonfield therefore became a natural place for a landing for goods to come in from Philadelphia as well as for products flowing into the city from the countryside. By 1815, it was known as Stoy's Landing and remained a major commercial center for most of the 19th century, even with improving roads and the coming of the railroad. In later years, the major export from New Jersey was timber. The major imports from Philadelphia were coal and manure to be used as farm fertilizer. The only remnants of this once-thriving business are the piers seen in the foreground.

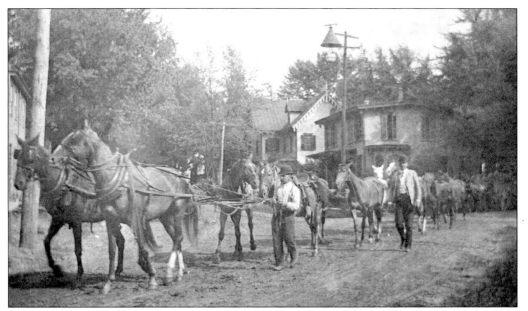

For years, horse-drawn wagons regularly brought products from as far away as the shore. Haddonfield was the last stop before proceeding to Camden and Philadelphia. The lower end of Potter Street had many sheds where horses were rested and fed. This photograph from about 1890 shows the juncture of Centre and Ellis Streets. By this time, large horse-drawn wagon trains were rare, with most freight being shipped by railroad.

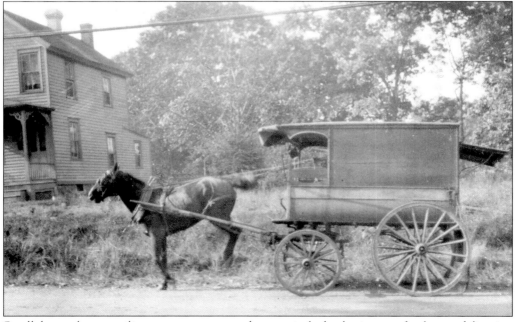

Small horse-drawn utility wagons were used extensively by businesses for home deliveries. Coal, ice, feed, milk, baked goods, meats, produce, and sundries from the general stores were all delivered by local businesses. Some Haddonfield businesses had regular delivery routes out of town, and some out-of-town hucksters regularly traveled into Haddonfield.

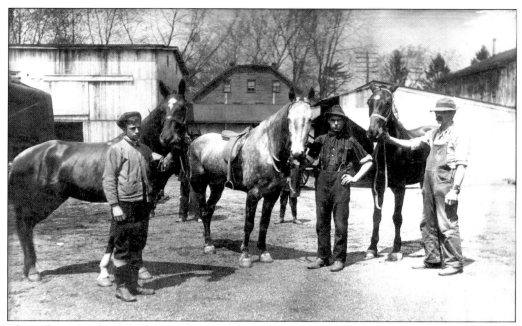

Throughout much of the late 19th and early 20th centuries, a horse transportation center was located behind Gibbs Tavern on Kings Highway along present-day Mechanic Street. Horses were bought and sold here. In addition, two livery stables operated there, providing early taxi services and horses for hire for both travelers and residents.

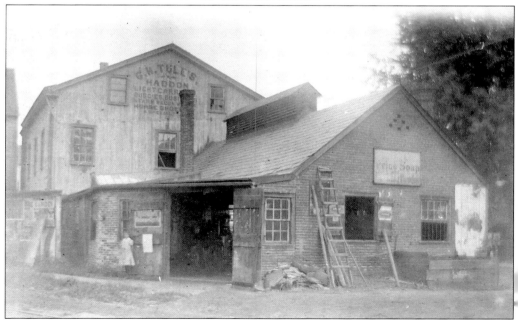

Tule's blacksmith shop at Haddon Avenue and Clement Street opened about 1859. The last blacksmith in Haddonfield, the shop closed in the early 1920s. In 1880, George Tule erected the large building behind the blacksmith shop where he manufactured carriages, buggies, and wagons. He advertised on the building "horse shoes a specialty."

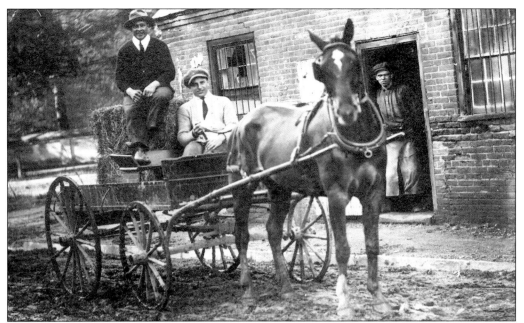

People were very proud of their horses and carriages, as the many pictures in family albums attest. The photograph, with Tule's blacksmith shop in the background, shows James Stretch seated in the carriage in the light jacket. Stretch, the local undertaker, also owned a nearby livery stable.

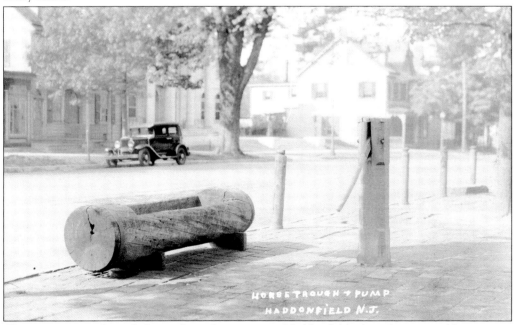

There were a number of places along the streets in Haddonfield where horses could get water. This wooden horse trough and pump stood in front of the Indian King Tavern on Kings Highway. There seems to be no functional connection between the pump and trough, and it is possible that the trough was placed here as an early nostalgic nod to the passing of the era of the horse.

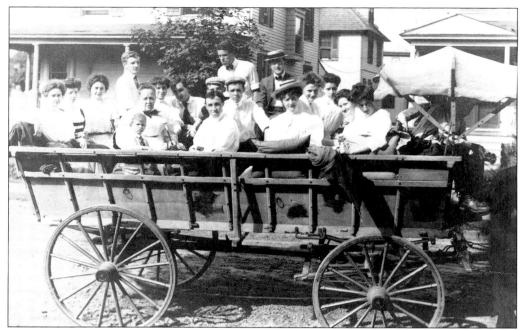

Large horse-drawn wagons used for harvesting and other farm work could also double as vehicles for recreational activities. This wagon, heavy duty enough to hold nearly 20 people, is being used for a Baptist church social outing in the early 1900s.

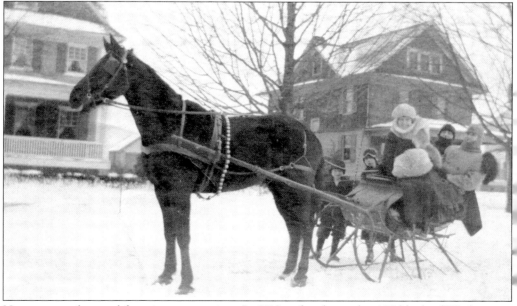

Horses were also used for winter recreation. In 1912, a family on the 400 block of Washington Avenue is prepared for an outing. Sleigh riding was a popular entertainment, and early newspapers and journals note that many people engaged in impromptu sleigh races along the main roads of town. Not merely for recreation, sleighs were a wintertime necessity, as carriages could not negotiate the dirt roads properly in the ice and snow.

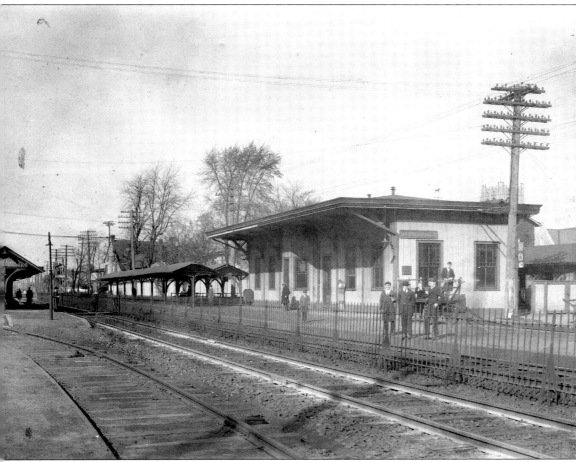

In 1853, the Camden and Atlantic Railroad came to Haddonfield. The railroad ran first from Camden to Long-a-Coming (now Berlin). Soon the line was extended to Atlantic City. The railroad's impact on the town was dramatic and relatively swift. The population of Haddonfield nearly tripled in size from 844 in 1850 to 2,502 in 1890. Many houses, especially in west Haddonfield, were built during this era to accommodate the many new permanent residents. Businesspeople, some of whom came to Haddonfield as summer visitors, could now live in a country village like Haddonfield and easily commute to work in Philadelphia. A second track from Camden to Haddonfield was laid in 1879, and by the late 1880s, there were 16 weekday train trips between Haddonfield and Camden. A tunnel under the tracks connected the main station on the eastern side with the smaller platform on the west. The railroad closed in 1966. Its track beds were used for a new high-speed transit service that began in 1969.

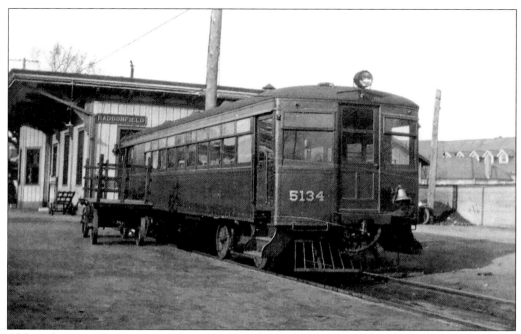

Although primarily a passenger line, the Camden and Atlantic Railroad was first conceived to be a freight line and served that role for many years. Another line, the Philadelphia, Marlton and Medford Railroad, began in 1881, and Haddonfield was where it linked to the Camden and Atlantic line. Although also a passenger line, it was primarily for farmers to get produce to market. It closed in 1932. (Courtesy of Mary Jane Freedley.)

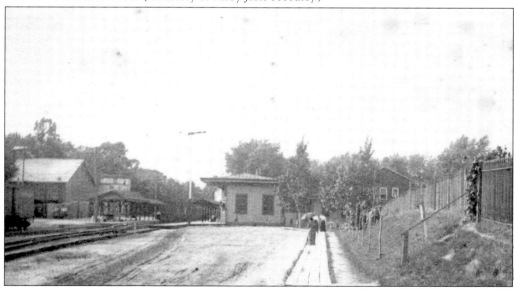

The railroad station was a community gathering place. Commuters and Haddonfield housewives heading to larger stores in Camden and Philadelphia were joined by shoppers from the outlying areas coming to Haddonfield's bustling business district and out-of-town students coming to Haddonfield for their secondary education. Weekends often brought church groups and individuals heading to the shore or the countryside for recreation.

Unlike today's high-speed rail line, the railroad ran at grade level. At the busiest intersection, Kings Highway, there were gate-crossing bars for the safety of pedestrians and automobiles. The gates were operated by gatekeepers who attended to their job from a small gatehouse situated on the southwest corner of the highway. The gatekeepers often tended a plot of flowers near their gatehouse.

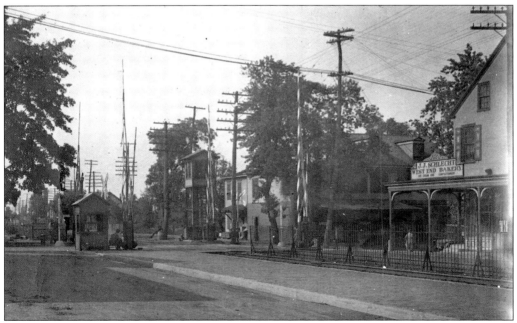

Just east of the railroad and a few hundred feet from the railroad station, Schlecht's West End Bakery thrived from 1874 to 1949. In addition to their bakery business, the Schlechts made their own ice cream, a popular item with the many railroad riders and residents. Capitalizing on their location near the railroad, the Schlechts also ran a livery stable and boarded horses while their owners took the train.

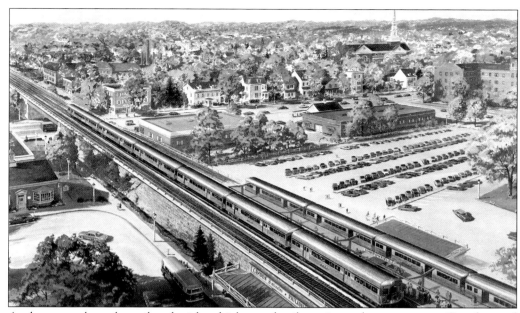

A plan to replace the railroad with a high-speed rail service to better connect Camden and Philadelphia with the nearby suburban towns was proposed by the Delaware River Port Authority (DRPA) in the late 1950s. Beyond downtown Camden, the rail line and all the stations, including Haddonfield, were to be elevated. The illustration above showed the proposed elevated Haddonfield station. Opposition in the community to the elevated line was fierce. The foremost argument was the fear that an elevated line would negatively alter the historic fabric of Haddonfield. After much negotiation, the DRPA agreed to depress the line through much of Haddonfield. Service on the high-speed line began in 1969 and continues to serve as an important transportation link for residents traveling to Philadelphia for work as well as recreational and cultural events.

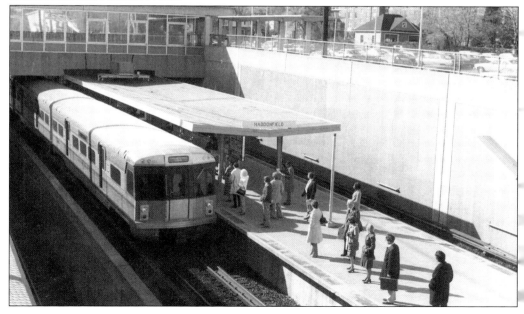

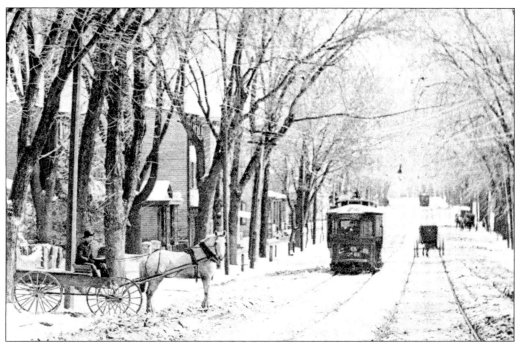

Trolley service between Camden and Haddonfield began in 1895 and ran 24 hours a day. The trolley came up Haddon Avenue to Kings Highway and turned right to the railroad. Later it came up Tanner Street to accommodate larger cars, which could not make the turn at Haddon Avenue onto the highway. At the railroad, a conductor turned the overhead pole and the car proceeded to Potter Street. The pole was turned again, and the trolley returned to Haddon Avenue and on back to Camden. Plans to extend the trolley into west Haddonfield were abandoned when the railroad refused permission for the trolley to cross its tracks. Trolley service ended in 1932 and was replaced by Public Service Corporation buses, shown below at the intersection of Haddon Avenue and Kings Highway. The growing number of automobiles also contributed to the trolley's demise.

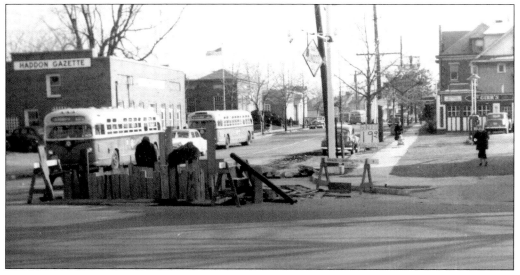

When automobiles arrived in the early 20th century, they were regarded at first with both curiosity and alarm. As early as 1909, residents of Grove Street were complaining of the many fast-moving automobiles, and it was recommended that the speed limit be eight miles per hour. The automobile also brought nearly unlimited mobility to the average person for the first time. This accelerated the pace of the suburbanization of Haddonfield.

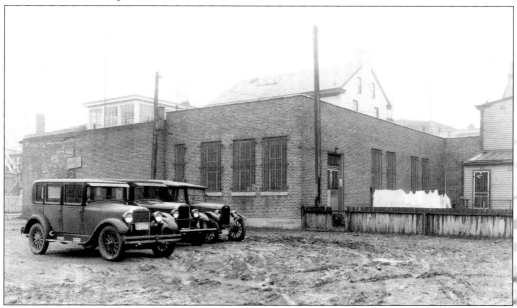

Automobiles require places for parking. As automobiles have grown more numerous, finding adequate and convenient parking has been a constant challenge in Haddonfield. The area behind Gibbs Tavern, accessed by Mechanic Street, was once an area of livery stables and other horse-related activities. In this 1929 picture, it is being used as an unpaved parking lot. Today it is one of a number of borough parking lots.

According to early officials, streets were always a problem, especially when they were dirt. This early-20th-century picture shows Ellis and Potter Streets, a major entryway to Haddonfield, and the conditions of the dirt roads. Difficult for both horse and automobile, the streets worsened as car traffic increased. Kings Highway became the first street to be paved in 1913, with other streets following over the next few decades. (Courtesy of Robert T. Henry.)

According to the note on the back of this photograph taken about 1910, this is "Wilmer Garwood, the picture nut." He is perched atop a sign that bids farewell to those leaving Haddonfield on Grove Street near the corner of Maple Avenue. The fact that there is a sign indicates the growing importance of automobile traffic.

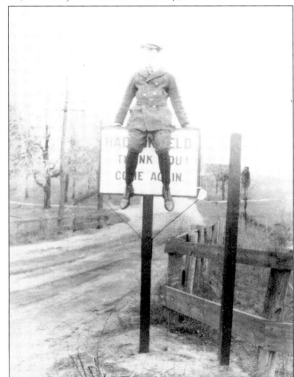

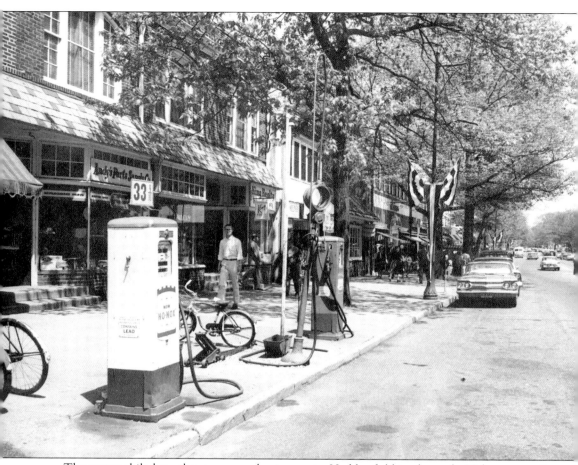

The automobile brought many new businesses to Haddonfield in the early 20th century. Stores specializing in tires or batteries appeared. In 1910, there was a Regal automobile dealer on Kings Highway, which later relocated to Tanner Street. As dealerships grew larger, a few were established on Haddon Avenue near the Haddon Township line. With limited space for growth, these dealers soon outgrew Haddonfield, and all relocated out of town by 1970. A few decades ago, there were as many as 10 gasoline stations operating in town, including many in the central business district along Kings Highway; there were three at the intersection of Kings Highway and Haddon Avenue at one time. More typical of early gasoline businesses, this 1962 picture of the 100 block of Kings Highway East shows the last of the businesses that dispensed gasoline from a pump by the side of the road. (Courtesy of Haddonfield Public Library.)

Two

BUSINESSES

The landscape of business in Haddonfield, both in the types of businesses and in the physical business district, has undergone vast changes throughout the centuries. What has not changed is the central business district as a defining feature in the life of Haddonfield.

While only a gristmill and a blacksmith shop predated the 1701 arrival of Elizabeth Haddon, many small businesses soon established themselves as the village began to form. From its earliest days, due mainly to its strategic location in the local transportation systems, Haddonfield became a regional business center serving people from a wide outlying area. Primarily located along Kings Highway, most early businesses were craftsmen, possibly working with apprentices, and included saddlers, shoemakers, blacksmiths, wheelwrights, clock makers, and cabinetmakers.

General stores, selling a wide variety of merchandise, first began appearing in the 1720s. Taverns, which served meals and provided rooms for travelers, soon followed. Some small industries, such as brickyards, tanneries, and a brewery, which exported beer to Philadelphia, also opened in the early 1700s.

In the 1800s, specialty stores, such as drugstores, began to appear. General stores continued, and most grew much larger. Aided by the coming of the railroad and the trolley and despite the ascendancy of Camden City, Haddonfield continued to be a vibrant regional business center throughout the late 1800s and well into the 20th century. In addition to shopping, recreational attractions, such as a movie theater and a bowling alley, also brought people downtown. Many businesses, including the bank and even the library, maintained Saturday evening hours for many years.

By the mid-20th century, as the surrounding areas grew and developed their own shopping districts and shopping malls emerged nearby, Haddonfield's role as a regional business center began to diminish.

Haddonfield gradually adapted to the changes in contemporary retailing, and despite the perennial challenges of a small-town business district, the town has been able to reestablish itself as a destination for specialty shopping as opposed to its former function as the place for basic necessities.

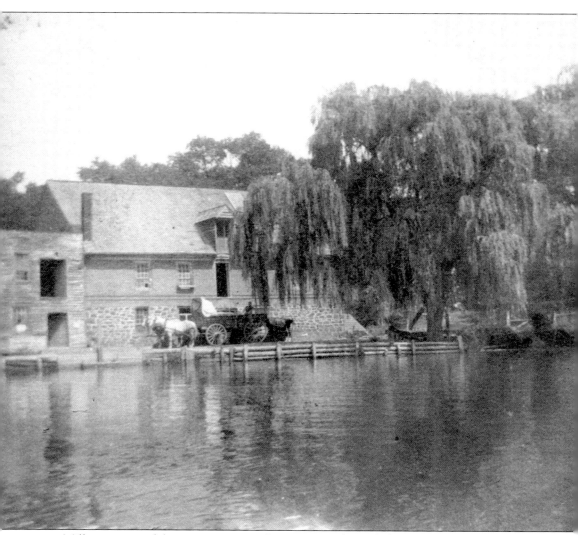

Mills were one of the most important businesses in the early history of Haddonfield. Evans Mill and other mills around the village speak to the dominance of agriculture in Haddonfield and vicinity for most of its history and also speak to its rapid decline. The mill at Evans Pond was the successor to one of the earliest mills in the area, Kendall's Free Lodge Mill, which existed near this site as early as 1696. Farmers could bring grain and stay for free until it was ground, hence the name. In this picture, Evans Mill was still an active gristmill being used for grinding grain. The rise of electrical energy and the decline of farming as the major business of the region eventually led to the closing of this mill in 1897, one of the last in the area. The building burned in 1913.

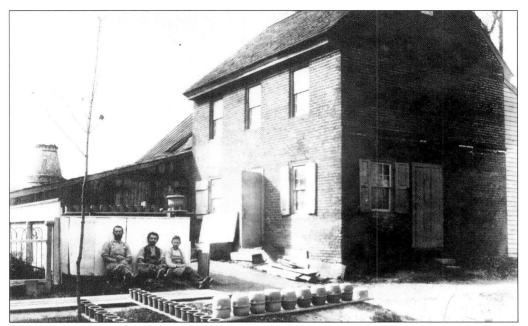

Pottery making was an early and important business in Haddonfield. This pottery was located at 50 Potter Street. Begun by John Thompson in 1805, it was continued by Richard Snowdon and his son until 1883. In the 1890s, the business was taken over by Charles and William Wingender, German immigrants who had learned the trade in Europe.

By 1904, the Wingender brothers decided to move the pottery to roomier quarters, building the pottery seen at 251 Lake Street and the brick twin to the left for their two families to occupy. The pottery operated until about 1957, although by then, they were primarily making clay pipe and flowerpots, having stopped making the decorative pots for which they had once been well known. (Courtesy of Haddonfield Public Library.)

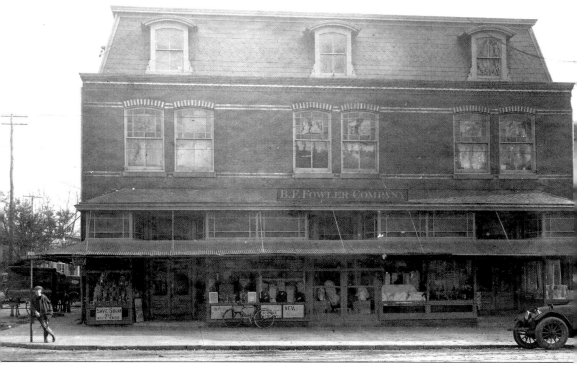

General stores arrived in Haddonfield as early as the 1720s, the first documented one being Sarah Norris's store at the west corner of Kings Highway and Potter Street. As the name implied, one could buy almost anything at a general store, including food for people and animals, liquor, clothing, fabric, hardware, tools, medicines, and many other items. Originally these stores tended to be smaller, serving the clientele of their neighborhood. As the town prospered in the late 1800s, many developed into small department stores with numerous employees. This photograph from the 1920s shows the largest and last general store in Haddonfield. Located at the west corner of Kings Highway and Ellis Street (now Kings Court), it was purchased by B. F. Fowler in 1906. Having owned his own modest general store for more than 30 years, Fowler embarked on a major new business venture with the purchase of this building. As business practices changed and perhaps due to the effect of the Depression, general stores began to fade, and Fowler's closed in the 1930s. The building was torn down and replaced by an A&P food store.

In 1859, Alfred W. Clement opened a general store at the east corner of Kings Highway and Ellis Street. Originally much smaller, the building was greatly enlarged in 1874, about the time he began his partnership with Thomas Giffin. The second and third floors were public meeting hall space, used by community organizations. This use continued into the 1960s when the YMCA occupied the space.

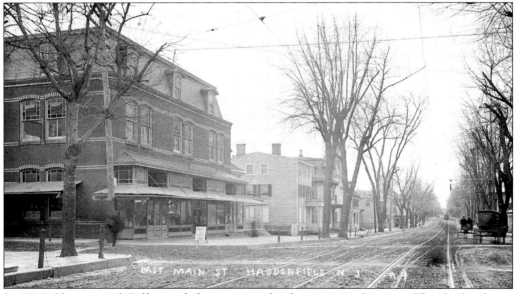

In 1886, Clement and Giffin needed more space for their growing business. They built a larger store directly across Ellis Street at the east corner of Kings Highway. With a few additions, the building soon extended nearly to Centre Street. The rear portion of the building was known as the opera house, an auditorium with seating for more than 400. (Courtesy of Anne and Boyd Hitchner.)

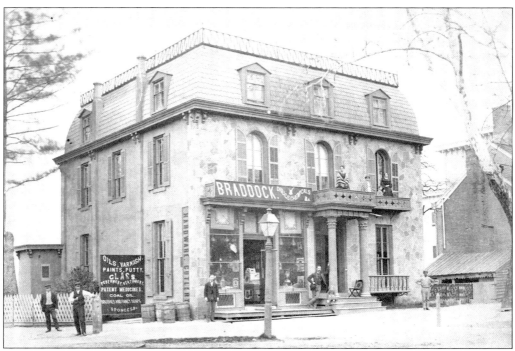

Braddock's drugstore was among the early specialty shops on Kings Highway. The Braddock family had been pharmacists since 1853. The building above is the pharmacy as originally built in the late 19th century. Typical of its time, the business was located in half of the first floor with the rest of the first floor and all of the upstairs used as the family residence. By 1902, the drugstore became a hardware store with a small, one-story addition to the shop, as seen below. The residential character of the rest of the building, however, clearly remained intact.

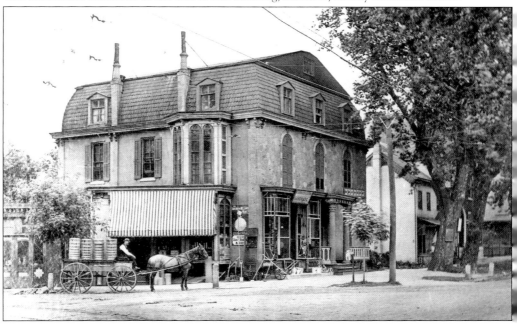

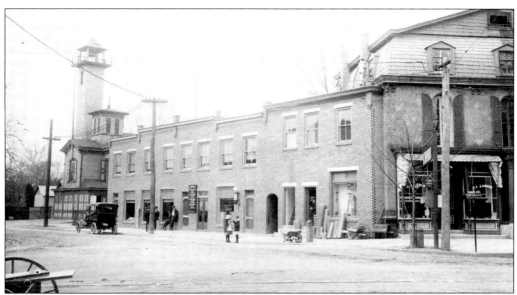

In the second decade of the 20th century, the Braddock building is still visible (above), but a major two-story building consisting of a number of shops on the first floor has been added to the Haddon Avenue side of the building up to the town hall and fire station. Lamont's hardware store took over the Braddock hardware store, but the old house is still discernable. By the 1940s, Kingsway Hardware and a shoe store occupy the first floor, and the residential character of the rest of the building no longer exists (below). Architecturally, the beauty of the underlying residence is undetectable, and the building is dominated by the two commercial fronts. (Above, courtesy of Anne and Boyd Hitchner.)

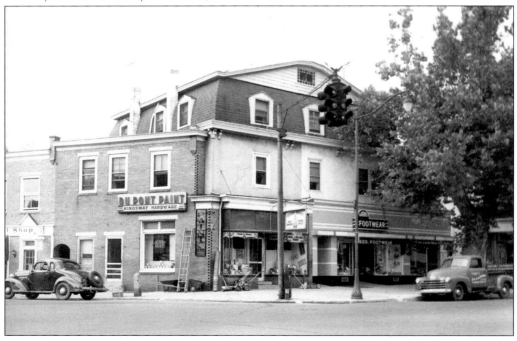

An early image of a horse-drawn wagon coming up Ellis Street to Kings Highway gives a unique view of the predominant Colonial, residential character of the street at the time. The left house, on the corner of Mechanic Street, became Willard's Telephone Drug Store in 1883, but the one next door, like many others, remained a residence. In the early-20th-century postcard below, the store facade on the front of Willard's respects the residential character of the street and neighboring houses while still indicating the commercial usage of the first floor. The fountain, visible in the front left corner of the picture, was erected by the Daughters of the American Revolution (DAR) in memory of Elizabeth Haddon Estaugh. It supplied fresh water for both man and beast.

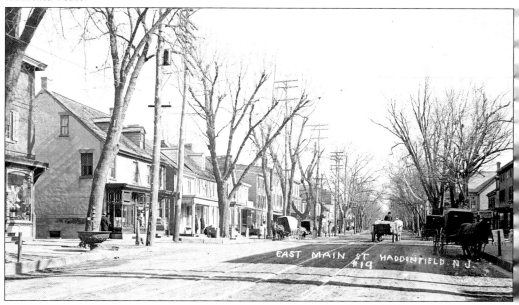

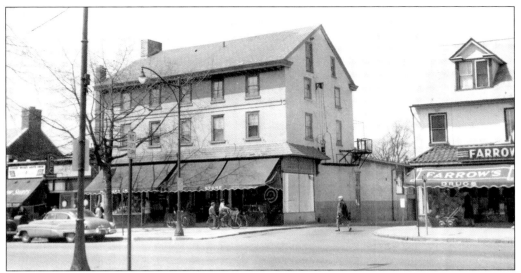

The change in use from residential to commercial of the house at 131 Kings Highway East is complete in this 1950s picture. Willard's became Farrow's in the 1920s, a change indicated by the modern neon sign that has been installed. Neumeyers store, still remembered by many for its old, worn wooden floors, daily newspapers, inexpensive toys, and candy for children, occupies the entire first floor of the 1777 Gibbs Tavern building.

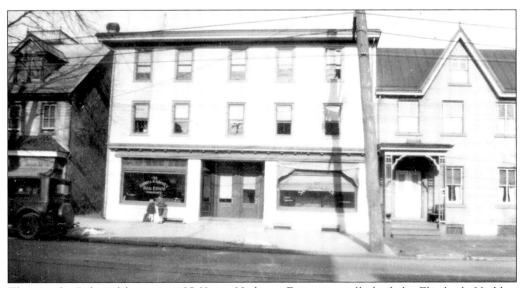

The simple Colonial house at 135 Kings Highway East, originally built by Elizabeth Haddon Estaugh as an investment property, is undetectable in the three-story, heavily altered commercial building seen in this mid-20th-century photograph. The growing commercial uses have taken over the historic house but have yet to reach the gothic Victorian next door at 139 Kings Highway, which is fighting the overwhelming commercial trend by remaining a residence.

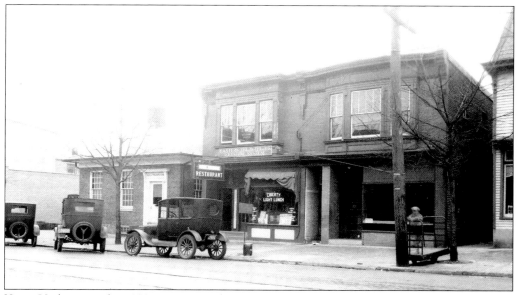

Kings Highway in the 1920s was an amalgamation of buildings that seemed to have practicality as their overriding theme. The Bell Telephone Company had outgrown its operation in Willard's Telephone Drug Store and erected the one-story brick building seen here at 111 Kings Highway East. Next to the telephone building, a twin brick with shops on the first floor and residences above started to become a common form of infill in the business district.

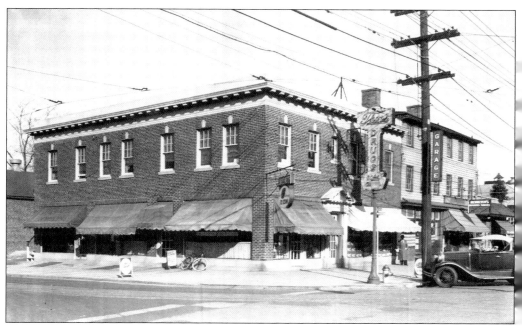

The corner of Tanner Street in the early 1900s saw the construction of a brick two-story commercial space that still exists today. In this picture, it is Thor's Drug Store, a popular shop with a soda fountain that was appreciated by residents of all ages. This was the beginning of the rise of the specialty store and of the slow decline of the large general stores.

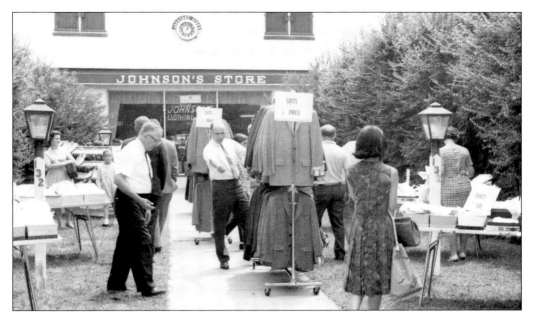

Johnson's Department Store at 132 Kings Highway opened in the 1940s and billed itself as "a city store at your front door." Johnson's building was set back from the street with a landscaped front that was especially helpful during summer sidewalk sale days, a long-standing and continuing annual tradition. Johnson's closed in the late 1960s, and the building was incorporated into the Colonial-style office building that was built in front of the earlier store.

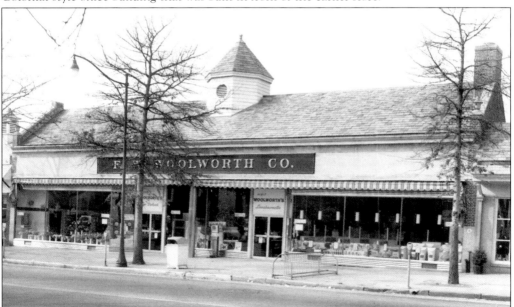

By the 1940s, the variety of architectural styles had created something of a hodgepodge in the business district. During World War II, the Haddonfield Civic Association suggested the formation of a beautification committee to help with the appearance of the area. That committee urged owners to Colonialize the facades of their businesses. Woolworth's, at 119 Kings Highway, was a successful example of what the Colonialization effort was trying to achieve.

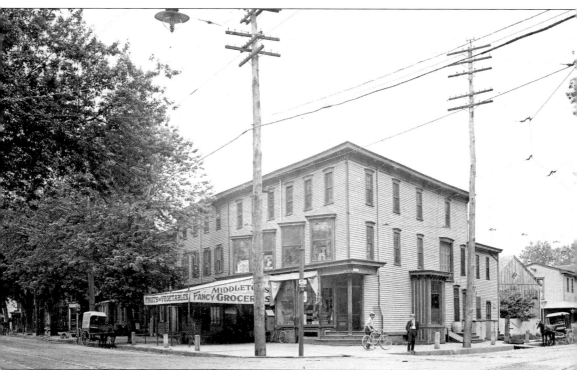

Although the general stores were both large and successful in the early 1900s, smaller stores, often run by a sole owner or family, also flourished in the Haddonfield business environment. Most of these stores specialized in a particular product. Bakeries, fish stores, butcher shops, green grocers, newsagents, feed stores, dry goods, and hardware stores were all represented along or near Kings Highway. The building at the northwest corner of Haddon Avenue and Kings Highway had been the first location of B. F. Fowler's general store, becoming Middleton's Fancy Groceries when Fowler moved to larger quarters in 1906. In 1914, it became the Philadelphia Bargain Store, a successful dry goods store run by Bernard Feinstein. The Feinsteins raised their family in the rear of the store. The eldest child, Isadore, who later changed his name to I. F. Stone, became one of the most famous and respected journalists of his day. The dry goods business closed in the early 1930s, and the building was torn down to make way for a gasoline station. Coming full circle, the gasoline station was replaced by a retail store.

Walter Dunphey, a former clerk at the nearby Fowler general store, posed in front of his store at 141 Kings Highway East. Dunphey was a dry goods dealer selling men's and women's furnishings, fabric and patterns, and even Haddonfield pennants. Dunphey, the last dry goods dealer in town, ran his business from about 1920 until 1946.

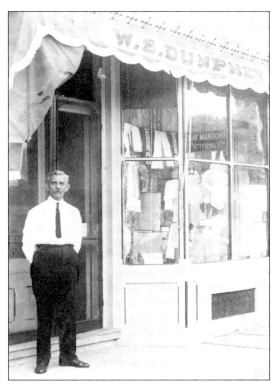

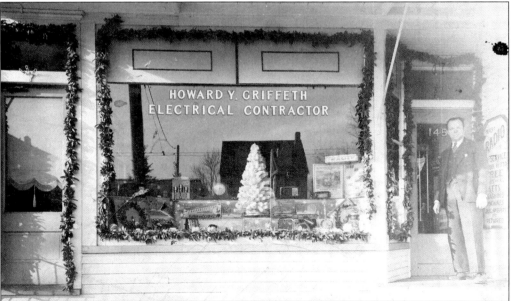

Griffeth Electric, a long-running business in Haddonfield, also began in the 1920s. Originally located on Tanner Street, Howard Y. Griffeth moved the business to 145 Kings Highway East in 1936. This 1938 photograph shows the reflection of the residence across the street in the store window. Although the retail store closed in 1991, the family business continues into the third generation. (Courtesy of the Parker G. Griffeth family.)

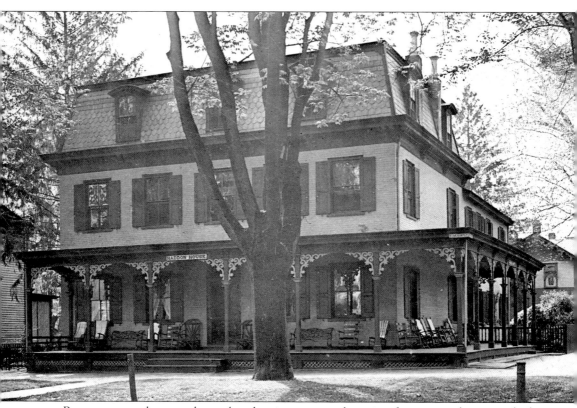

Restaurants and taverns have played an important role as significant contributors to the business community in Haddonfield. In earlier times, the taverns offered travelers and their horses both food and sleeping accommodations. At one time, Haddonfield had five taverns. After the town banned alcohol sales in 1873, some taverns continued as restaurants and hotels, while others opened specialty restaurants in the business district. Located at the corner of Potter Street, the Haddon House was opened as a hotel and restaurant by Thomas Baxendine in the late 1800s. Haddonfield was considered a summer retreat from Philadelphia, and the Haddon House was a popular destination for those escaping the heat of the city. Baxendine's daughters continued to operate it into the 1920s and developed an exceptional reputation for good food and hospitality. In 1931, the hotel had 16 rooms and a restaurant that continued to operate under various owners until about 1957, when the property was converted from a restaurant to an office building, a use that continues to the present. (Courtesy of Anne and Boyd Hitchner.)

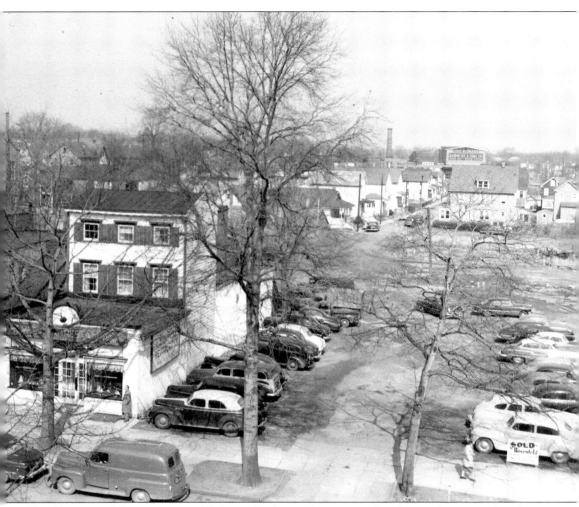

The Homestead Restaurant at 33 Kings Highway East, a popular fixture for many decades, is seen at the front left of this 1952 photograph. The picture shows how residences in the business district were not necessarily demolished. Instead, one-story commercial fronts were simply added to the fronts of the old houses, creating first-floor commercial space and retaining residential space above. In the foreground is an area that had been used as an informal parking lot for many years. At the time of this picture, a proposed store brought the issue of a lack of adequate and organized parking to a head. The construction of an office building on the vacant lot resulted in the building of an early municipal parking lot in the rear of these properties. The rear of this photograph shows an area of modest residences known as the Thousand Islands. Built in the second decade of the 20th century, many were torn down in the 1960s for parking lots for the new high-speed rail line.

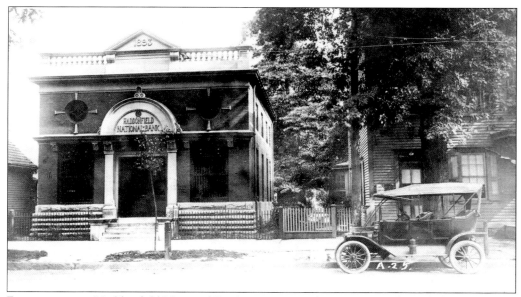

For many years, Haddonfield National Bank, incorporated in 1889, was the only bank in town. This building, designed by architect Clement Remington, was built in 1894 at 110 Kings Highway East. Although this building is no longer visible, it is actually incorporated into the bank building that still stands at that location. In recent years, banks have proliferated in Haddonfield.

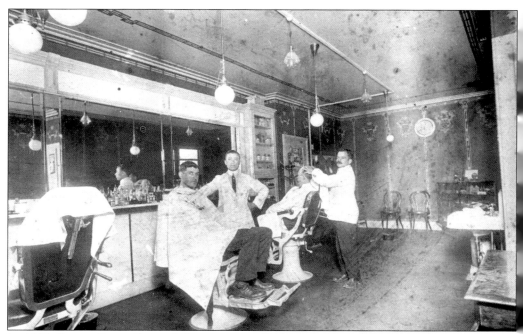

In 1902, Ernest Caravelli, an Italian immigrant, opened Caravelli's Barber Shop at 10 Kings Highway East. The shop remained in the family through 1998. As Haddonfield's oldest business, it continues today virtually unchanged at its original location.

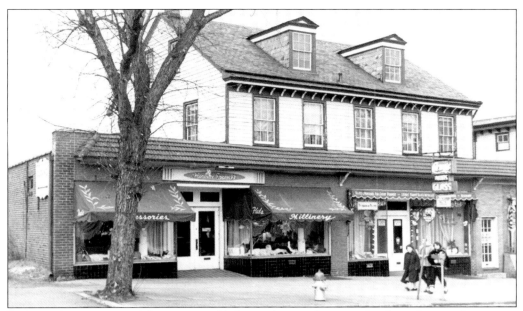

The way that commercial fronts were added to earlier residences is clearly evident in this picture of 1 Kings Highway East from the 1950s. A millinery shop and Cave's Frame and Mirror Shop occupy the first floor of the property with little regard for the structure that looms above it. Many commercial businesses have occupied these premises over the years, including Villa Rosa Italian Restaurant. (Courtesy of Haddonfield Public Library.)

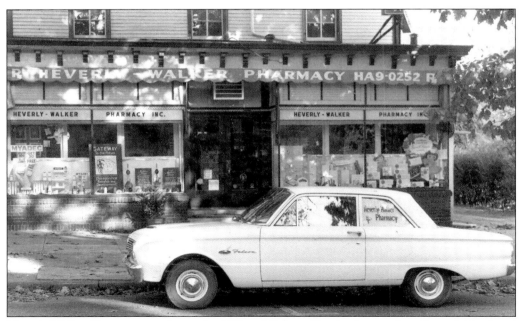

Heverly-Walker Pharmacy was located at 9 Kings Highway East in the era of smaller neighborhood pharmacies. All the pharmacies used to run delivery services, and Heverly-Walker proudly displays its Ford Falcon delivery sedan in front of its 1960s storefront. For a number of years, the space has been occupied by the Haddonfield Antique Center, an antique dealers' cooperative.

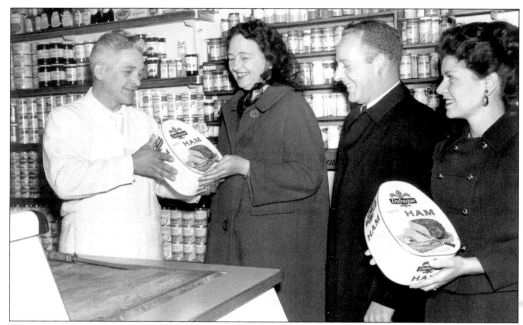

Ellis Meat Market was a long-established business that operated from a small building next to the Baptist church. Typical of the small, family-owned shops that historically had dominated food businesses, the owner or a clerk waited on customers personally and filled orders. Ellis Meat Market was torn down in 1951 to make way for a new A&P.

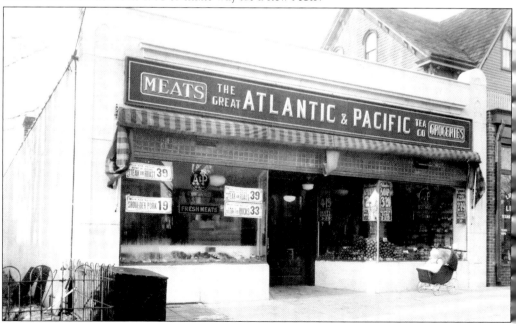

The Great Atlantic and Pacific Tea Company, better known as the A&P, opened a small grocery store in the center of the business district about 1920. Over the next few decades, it engaged in a fierce rivalry with the American Company Stores for dominance of the grocery business in Haddonfield.

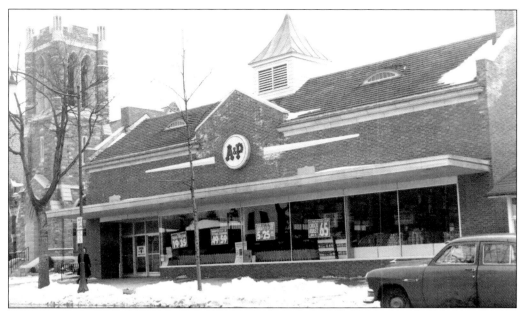

In the late 1930s, the A&P demolished Fowler's general store and built a modern store just a few doors away from the recently constructed Acme Market. In little more than a decade, the A&P decided to build an even larger store. On the former site of the Ellis Meat Market, it constructed a new store with Colonial architecture to conform to the wishes of the local beautification committee. (Courtesy of Haddonfield Public Library.)

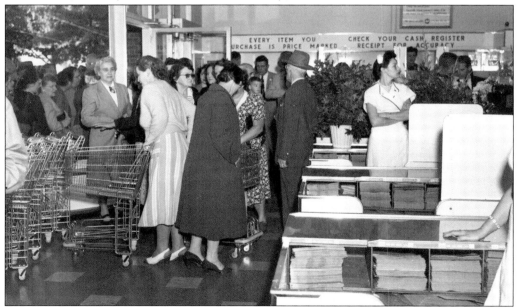

Although grocery stores had been growing larger, and self-service operations were long established, the opening of the new A&P in 1951 was a major event in town. Long lines formed outside on Kings Highway, as people waited to see the first grocery that could be termed a supermarket. The A&P closed in the 1970s, and the building was converted to retail space, housing a number of businesses.

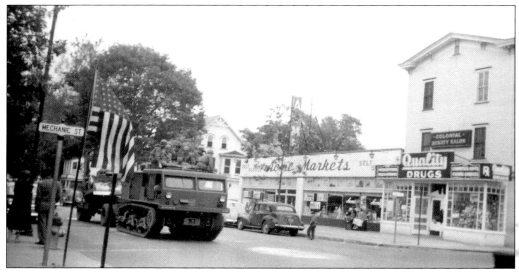

In 1910, American Company Stores had a market at 100 Kings Highway East. By the late 1930s, a modern Acme self-service market had been built at 204 Kings Highway East, the site of the CVS store today. In this photograph, a tank is passing by in preparation for a Haddonfield parade.

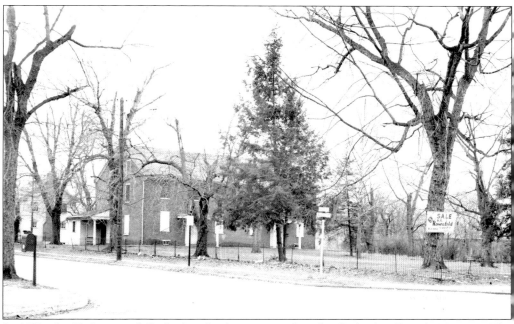

In 1952, the Hicksite and Orthodox Quakers reunited at the Orthodox Friends Meeting. The Hicksites decided to sell their building and grounds at Walnut and Ellis Streets, with the restriction that the meetinghouse could not be demolished but would be incorporated into any reuse of the property. Acme Markets, perhaps smarting from the new Colonial A&P on Kings Highway, bought the 1851 Friends meeting and incorporated the building into a new store.

In early 1954, Acme purchased three houses adjoining the Friends property, moving one to Fowler Avenue and tearing down the others. It then moved the Friends meetinghouse to the Ellis Street side of the lot and began the work of converting the former house of worship into a large, modern, self-service, grocery store. Borrowing various Colonial elements and incorporating them into the design, the Acme market opened in 1955. It continues to serve Haddonfield as the only grocery store left in town.

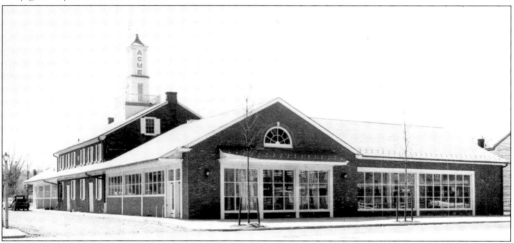

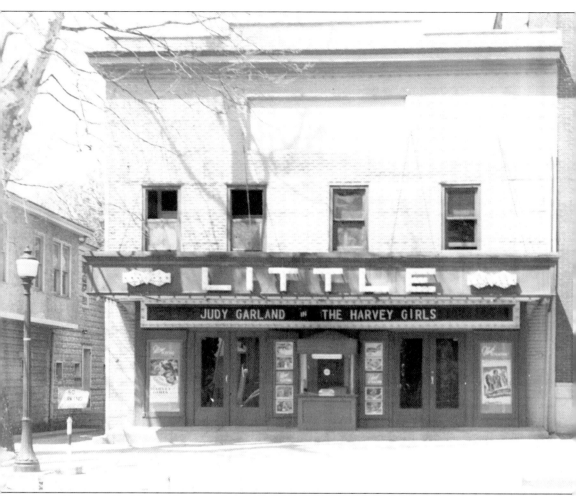

Because Haddonfield was a destination community for much of the area, the town offered recreation in addition to shopping in earlier times. There was a bowling alley on Tanner Street that was very popular as well as a movie theater. The movie theater was always located at 207–209 Kings Highway East, although it went through many names and owners, including Haddonfield Photo Play House, Classy Kingsway, the Bright Spot, the Colonial, and in the 1930s, the Little Theatre. At the time this photograph was taken, the theater could seat 353. It was segregated until shortly before it closed. African American patrons sat in a few designated seats in the balcony. As the larger theaters of Westmont and Collingswood drew most patrons away from Haddonfield for their movie entertainment, the Little Theatre closed in 1951.

Three

COMMUNITY SERVICES

Like all communities, Haddonfield has been shaped by how it comes together through organizations, government, and public gathering places.

Haddonfield has a long, rich tradition of good civic stewardship, and its residents work together toward common goals. The first community organization was the Friendship Fire Company, founded in 1764. In an era when fire was a constant threat, there could be no greater community service than volunteers always ready to help each other. Continuing today as Haddon Fire Company No. 1, it is the second-oldest volunteer company in the nation.

Government services have developed and expanded greatly over the years. First a part of Newton Township and later renamed Haddon Township, Haddonfield became its own borough in 1875. A few decades before, Haddonfield nearly became the seat of Camden County, which separated from Gloucester County in 1844. Camden, the rising economic and political power of the region, eventually was chosen as the county seat. It is hard to contemplate how differently Haddonfield would have developed had it become the center of county government.

For years, the social life of the town revolved almost exclusively around the churches. By the late 1800s, many secular organizations had formed, and by the dawn of the 20th century, there were no less than eight public meeting halls in town. Some groups were fortunate to have buildings of their own. More often the groups rented space, and a number of businesses along Kings Highway added meeting halls, typically on their upper floors, to meet this growing need. Only a few of the many organizations in Haddonfield can be highlighted here, with the focus mainly on those with a physical presence in the community.

An extraordinary number of organizations of all kinds, including fraternal, civic, educational, and service groups are active in Haddonfield today. Many have long histories stretching back for decades and even centuries. The strong sense of community spirit in Haddonfield has much to do with their vibrancy and the commitment of these organizations to the town.

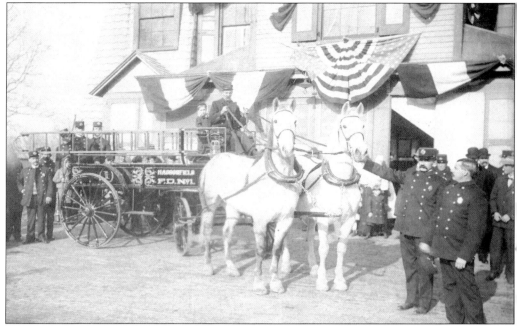

Only the 1721 Friends meeting has a longer history in Haddonfield than the fire company. Founded in 1764 as the Friendship Fire Company with 26 members, it is the second-oldest volunteer fire company in continuous existence in the country. Early firefighting equipment was minimal, and each member had to supply two leather buckets; the company supplied six ladders and three fire hooks. An early hand-pumped apparatus was purchased in 1818, and a small engine house was erected on land owned by the Quaker meeting to house it. In 1858, a new engine house was built on Haddon Avenue between the Friends cemetery and the recently erected town hall. Within a few years, the fire company moved its equipment into the first floor of the town hall. (Courtesy of Haddon Fire Company No. 1.)

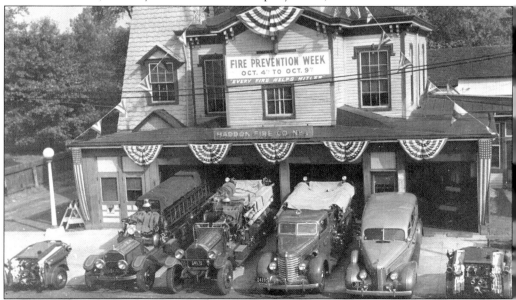

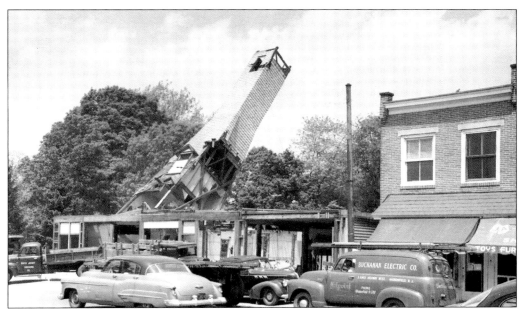

The first motorized fire truck was purchased in 1916, and eventually bays were built in the front of the building, almost reaching the street, to accommodate the larger equipment. In 1928, the fire company became the sole occupant of the building. As the amount of firefighting equipment increased and fire engines continued to grow bigger, even the use of the entire building was inadequate. In 1951, the building was demolished. The most prominent feature of the building, the tower used to dry the fire hoses, is seen coming down. The present building was completed in 1952. Over the years, the name of the organization has changed a number of times, but since 1887, it has been known as Haddon Fire Company No. 1. The fire company maintains a small museum, which includes the hand-operated pumper that was bought in 1818.

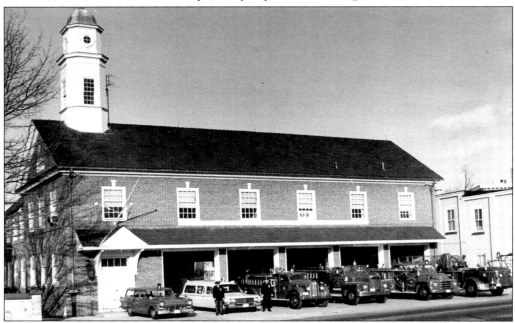

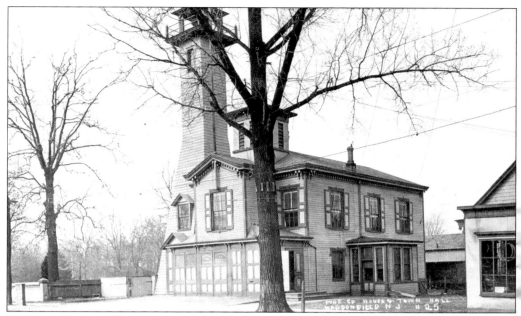

Haddonfield originally was part of Newton Township and later Haddon Township. The town hall was built in 1854 for Haddon Township. It was constructed on Haddon Avenue on the site of the Quaker meetinghouse, which had been demolished in 1851. Over the years, it housed public school classrooms, the police department, the Haddonfield Library Company, the fire company, and all borough offices. In 1875, Haddonfield was incorporated as a borough but had limited autonomy and remained partly tied to Haddon Township until 1898. When it became fully autonomous, it first functioned with a mayor and council. In 1913, the three-person commission form of government was adopted and continues to this day. This photograph from about 1925 shows the interior of the building with some of the borough officials. Mayor Joseph Lippincott Jr. is on the far left. (Courtesy of the Borough of Haddonfield.)

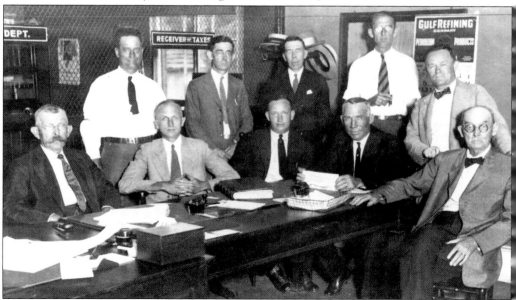

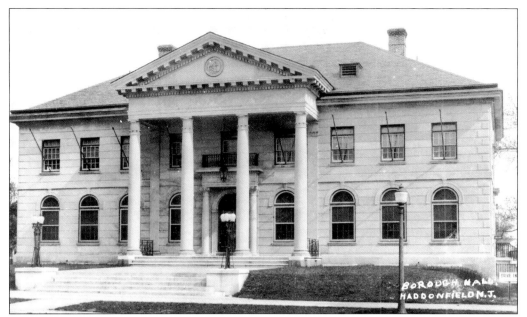

By the 1920s, borough services had greatly expanded. Coupled with the need for parking for borough employees, the police, and citizens doing business with the town, a new borough hall was erected at 242 Kings Highway East in 1928. The old town hall was turned over to the fire company for its exclusive use.

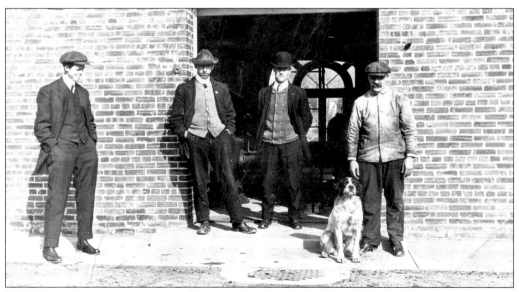

In 1886, a private water company began to lay pipe, and two years later the first houses began to directly receive water. Not satisfied with the quality of the water, Haddonfield voted to establish a municipal waterworks in 1905. The photograph shows the first municipal water plant, constructed in 1910 near Centre Street on the site of today's public works department. (Courtesy of Anne and Boyd Hitchner.)

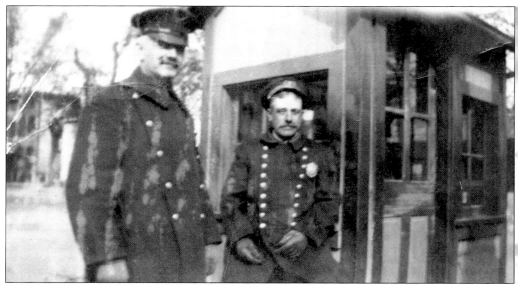

For nearly 200 years of its history, there were no police in Haddonfield. Soon after becoming a borough in 1875, a special constable was appointed. In 1879, the town night watchmen were deputized as police, and in 1881, a lockup was placed in the town hall. By 1898, the borough named a marshal of police, the equivalent of a chief of police. The first with the title of chief was John Van Leer, shown on the left in the photograph above with an unidentified policeman. The photograph below dates from about 1913, the year the police became an official department of the borough. The earliest police did beat duty on foot. Soon bicycles were added, followed by motorcycles. (Above, courtesy of Haddonfield Police Department.)

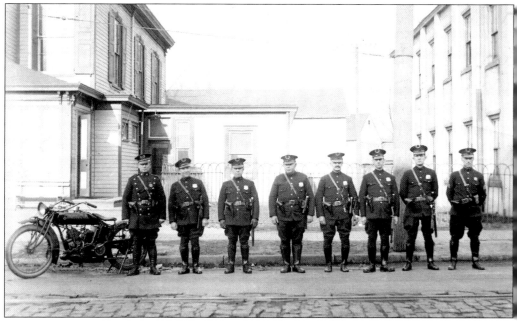

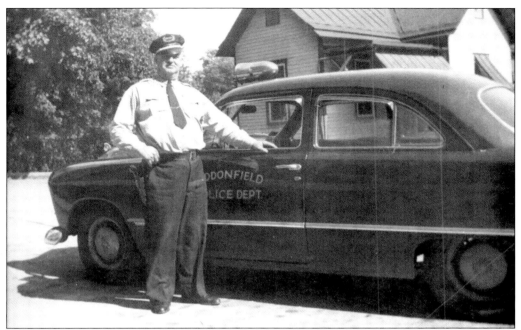

Along with the growing borough, the police force grew steadily as well. Probably the biggest factor affecting the need for more officers was increased automobile use, or more specifically, the traffic they generated. For many years, officers were regularly scheduled to direct traffic at the major intersections in the central business district on Kings Highway. The police department also quickly added cars, which were soon equipped with radio transmitters for patrol duty and to respond to emergencies. Howard Albertson Jr., a member of the police department from 1926 to 1962, is shown above with one of the police cars in 1949. Below is the police force in 1955 in front of the borough hall with Mayor Ernest Farrington.(Courtesy of Haddonfield Police Department.)

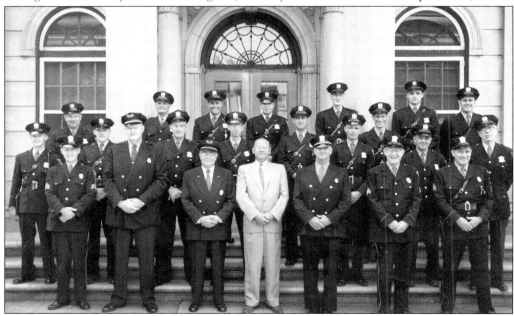

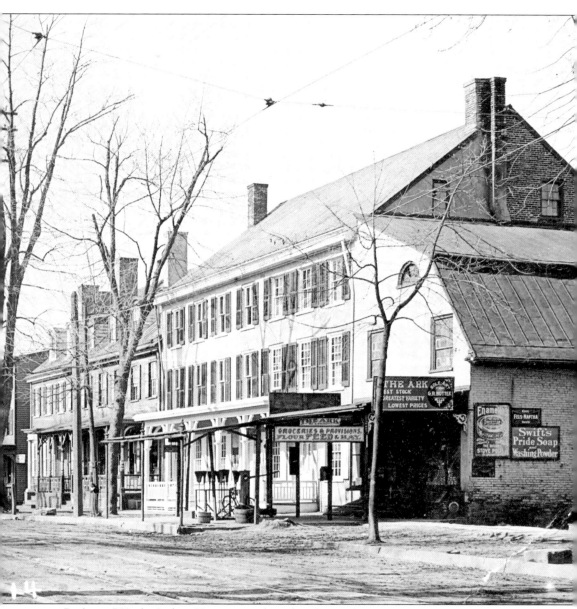

Built in 1750, the Indian King Tavern has played a number of roles in the life of Haddonfield, first as an important early business and later as a gathering place for community organizations and as a museum. Historically, it is best known for its role in the American Revolution. Throughout 1777, the New Jersey Colonial legislature, on the run from the British, often met at the tavern. Here they officially declared New Jersey to be a state rather than a colony and they adopted the great seal of New Jersey. In 1873, Haddonfield voted to prohibit the sale of alcohol; it remains a dry town today. Trying to adapt to life without a liquor license, the former tavern began advertising itself as the American Temperance House, continuing as a hotel and boardinghouse. Gradually it fell on hard times and was in a rundown condition. Recognizing its seminal role in the early history of the state, New Jersey acquired the building in 1904 as the first state-owned historic site. A commission of local citizens was appointed to oversee the site.

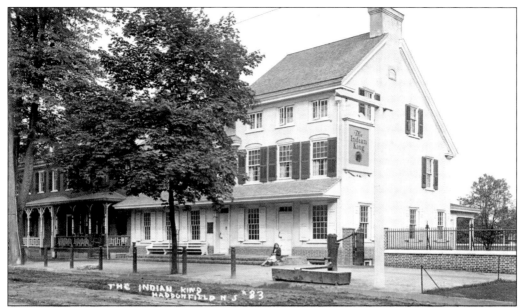

The state soon extensively altered the Indian King Tavern, designing it with a Colonial Revival theme, which dominated architecture at the time. The photograph below shows the Friends Historical Society viewing the recently renovated site about 1910. As part of the restoration, the pre-Colonial-era gambrel-roofed structure on the east side of the building was removed. Built about 1764, it originally was part of the tavern operation. From 1842 to 1904, it was a general store known as the Ark. For many years, a number of civic and historical groups met at the Indian King Tavern. The Haddon Fortnightly, the DAR, the Sons of the American Revolution, and the Daughters of 1812 maintained and furnished their own rooms. The organizations vacated the property many years ago when the state brought the site up to more contemporary museum standards.

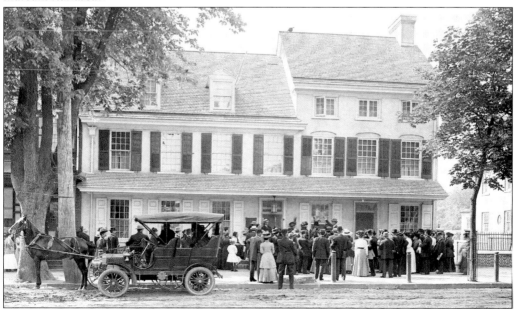

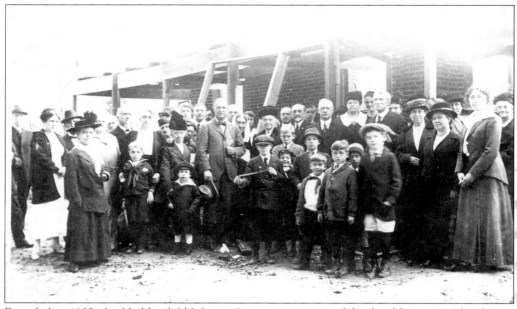

Founded in 1803, the Haddonfield Library Company was one of the first libraries in New Jersey. A private organization, nonmembers could borrow books for a small fee. In 1887, a second library, the Haddon Athenaeum, was established. Unlike the traditional Haddonfield Library Company, it purchased novels and soon became the dominant library. Deciding that one library would better serve the community, the Haddonfield Public Library was approved by voter referendum in 1909. By around 1915, a great civic effort raised funds for a new building to house both the library and the newly formed historical society. A lot at Haddon Avenue and Tanner Street was donated, and the cornerstone laying, shown above, took place in 1917. Opened in 1920, it remains the home of the Haddonfield Public Library. The historical society moved to separate quarters in 1938 due to overcrowding.

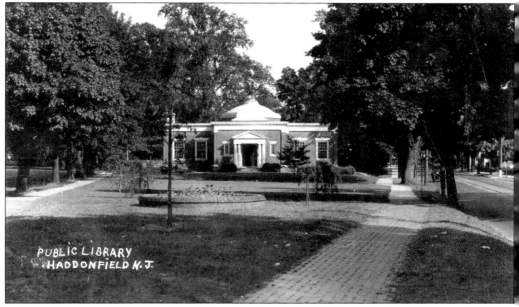

Mail was irregular in early Haddonfield, and it was not until 1803 that the first postmaster was named. In the 1820s, twice-weekly mail delivery was established between Camden and Haddonfield, coming via an early stagecoach route. People went to the post office to get their mail. It was not until about the dawn of the 20th century that mail carriers began to deliver mail directly to homes and businesses in town.

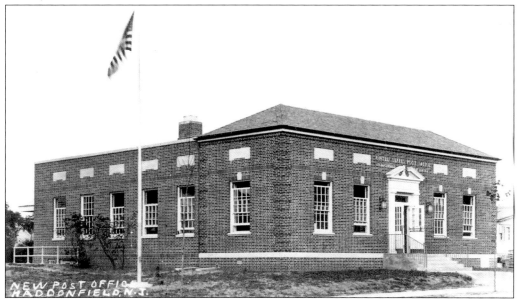

The post office had many locations along Kings Highway over the years. The postmaster often was the owner of a general store and the post office was located in his place of business. The post office briefly occupied a building of its own on Kings Highway in the early 20th century, but not until the building of the current post office on Haddon Avenue in 1935 did it have a permanent home.

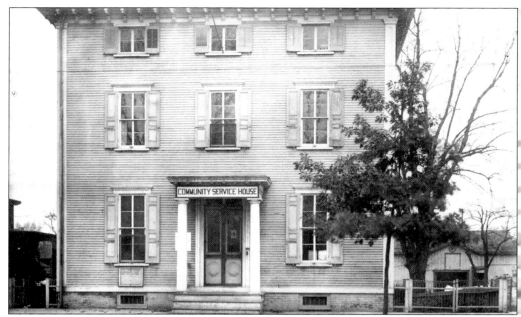

A mother who had lost her young daughter to diphtheria founded the Loving Service in 1902. The initial goals of this women's service club were modest, mainly bringing flowers to shut-ins. By 1912, visiting nurses were added, providing skilled care for young mothers, handicapped children, and patients with chronic illness. Physical therapy and nutritional supervision were provided as well. Housed first in the Masonic temple, they acquired their first permanent home during the second decade of the 20th century, the Community Service House, seen above at 37 Kings Highway East. In the mid-1920s, it moved to 104 Centre Street. The Loving Service eventually evolved into the Haddonfield Visiting Nurses Association. It operated into the 1980s and was housed for many years in the building behind borough hall seen below. The building now houses Interfaith Caregivers, an organization that assists the elderly and disabled to live independently.

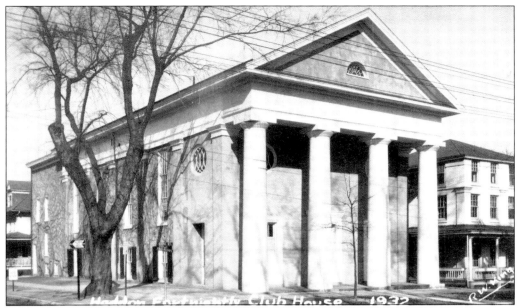

Since 1931, the former Methodist church at Grove Street and Kings Highway has been home to the local women's organization, the Haddon Fortnightly. From 1911 to 1931, the Artisans and other civic groups used the building. Threatened with demolition in 1922, it was purchased by the Haddonfield Civic Association, which considered the space too valuable to lose. Almost immediately after being acquired by the Haddon Fortnightly, the distinctive and now iconic columns were added.

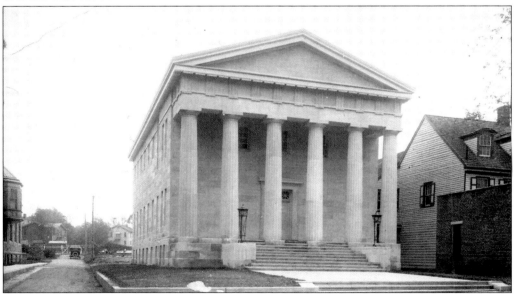

The Masons were the most prominent and visible of the many fraternal societies that became active in Haddonfield during the Victorian era. Founded in 1872, they built their first temple in 1884 at Washington and Lincoln Avenues. Rather than remodel the original temple, the Masons decided to build a new temple. A lot was purchased next to the Presbyterian church on Kings Highway, and the current temple was opened in 1922. (Courtesy of Anne and Boyd Hitchner.)

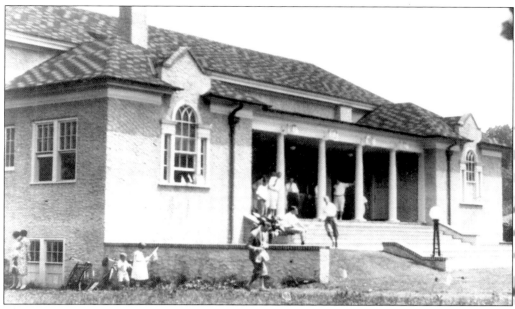

The Birdwood Club, built in 1925, stood at 419 Hawthorne Avenue. The developer of the surrounding Birdwood tract envisioned it as a neighborhood clubhouse for family and social gatherings. By 1930, it tried to be self-supporting with supervised dances and indoor and outdoor recreational activities. This proved unsuccessful, and it became the home of the American Legion Post 38 from 1946 until 1989, when the legion relocated, and the building was demolished.

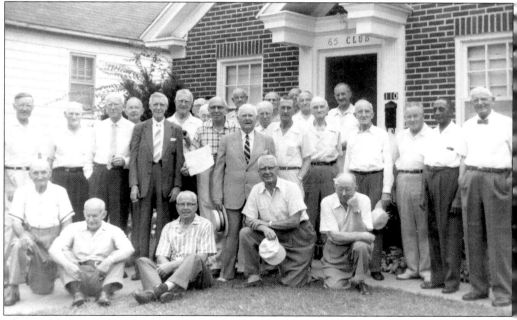

The establishment of a club for retired men of the borough was first proposed in 1954 and quickly came to fruition. Incorporated in 1955 as the Haddonfield 65 Club with an initial membership of 38, the borough commissioners granted the club the use of the little-used election polling building at 110 Rhoads Avenue. It remains their headquarters today.

Four

CHURCHES

Religion, particularly the religious persecution of Quakers in England, was an essential reason that the town of Haddonfield was settled. John Haddon and his family were devout Quakers who had frequently experienced the persecution to which believers were subjected in England. A prominent and influential businessman as well as member of the Religious Society of Friends, Haddon believed that the establishment of Quaker settlements in the New World offered the best chance of survival for Quakerism. In order to implement his beliefs, Haddon purchased land in West Jersey with the intent to bring his family to settle and to establish a Quaker meeting in the area. Although he never came to West Jersey, he supported his daughter Elizabeth and her husband, John Estaugh, a Quaker minister, in their efforts to establish a community where Quakers could practice their religion. In 1721, when Elizabeth was visiting her family in London, Haddon gave her a deed for an acre of land on what is today Haddon Avenue for a Friends meetinghouse and burying ground. The first two Friends meetinghouses were located on the site of the present fire company building adjacent to the original Friends cemetery that has been expanded over the years to its present size.

Following the first century of Quaker dominance of the area, other denominations slowly began to hold services and erect houses of worship. The first to come were the Baptists, who began holding services in the Grove School building in 1817. In 1818, they purchased land for their own meetinghouse on Kings Highway East opposite the current high school. They were quickly followed by the Methodists in 1829, the Episcopalians in 1841, and the Presbyterians in 1858. The growing African American community began construction of Mount Pisgah African Methodist Episcopal Church in 1887 followed by Mount Olivet Baptist Church in 1894. The 20th century saw the arrival of the Bible, Lutheran, Christian Science, and Catholic churches in town. Although many of the churches have had multiple buildings at multiple locations, they all continue to be active to the present day.

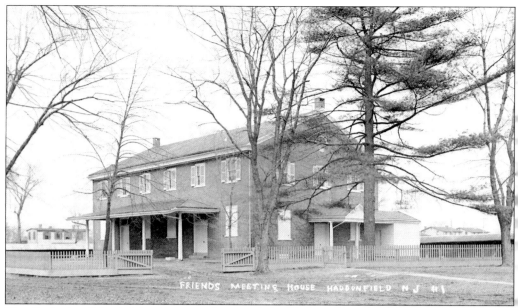

The Orthodox Friends Meeting seen above and the Hicksite Friends Meeting seen below were both built in 1851 following the demolition of the 1760 brick Friends meeting that stood on Haddon Avenue at the site of the present fire company building. The two groups had acrimoniously shared the earlier meetinghouse for 20 years until the Orthodox Friends were awarded ownership by the courts and promptly tore it down. Both groups then built almost identical meetinghouses; the Orthodox were on Friends Avenue at Lake Street, and the Hicksites were on Ellis Street at Walnut Street. The two meetings continued to operate independently until 1952 when the Orthodox and Hicksite Friends were reunited. The Orthodox meetinghouse was chosen as their house of worship, and the Hicksite meetinghouse was sold to Acme Markets to be incorporated into their new grocery store.

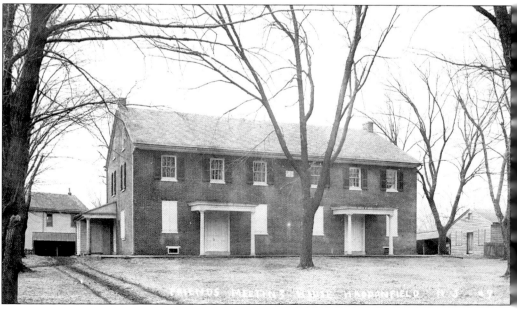

The first denomination to come to town after the Quakers was the Baptists, who began with services in the Grove School in 1817. By 1818, they bought the land used today as the Baptist cemetery on Kings Highway East and erected their first church, which looked very much like a Quaker meetinghouse. In 1852, they decided to tear down the 1818 building and build the sandstone church seen here. By 1885, the membership purchased the lot at 124 Kings Highway East and built a third church, the stone building designed by Isaac Purcell seen in the picture below. Today the decorative tops of the tower and the pilasters have been removed due to deterioration over the years. The First Baptist Church of Haddonfield continues as an active and vibrant member of the community. (Courtesy of Anne and Boyd Hitchner.)

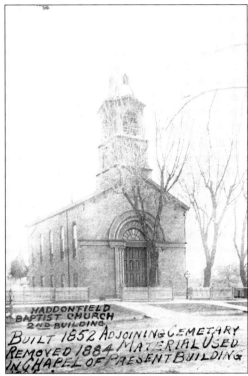

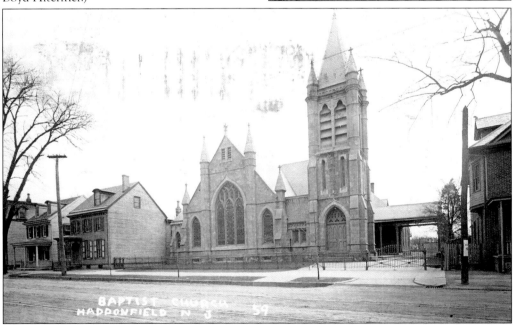

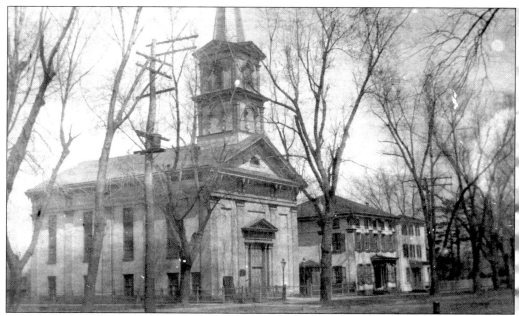

The Methodist congregation has had more church structures and locations in Haddonfield than any other religious denomination. After starting out at the Grove School in 1829, a simple meetinghouse at the east end of town in the Methodist cemetery was built in 1835. In 1857, they purchased land at the corner of Kings Highway and Grove Street and built the church seen here for their growing membership. (Courtesy of Joyce Hillman Hill.)

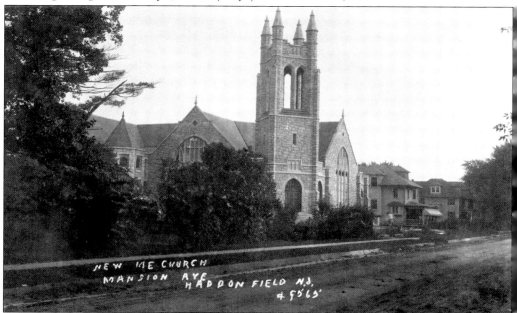

By 1909, the Methodists were again looking for land for a new church building. This time, with a generous donation from Henry D. Moore, they purchased a lot on Warwick Road near Kings Highway West. In 1912, the stone structure seen in this picture became the new home of the Methodist church. (Courtesy of Anne and Boyd Hitchner.)

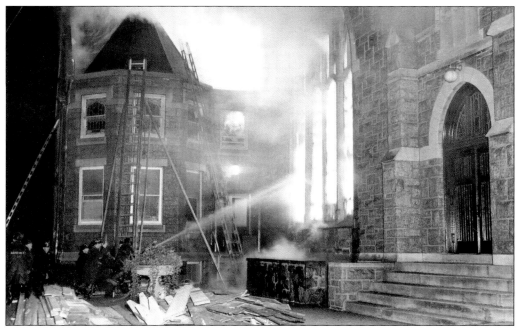

The beautiful stone Methodist church on Warwick Road was a cherished home for the congregation until October 1955, when a nighttime fire erupted and totally destroyed the building. It was a spectacular fire that was visible for miles and still vividly remembered by those who came to see it that dark night. Out of the ashes of the fire, a beautiful, new, brick Colonial church rose on the site. This interior photograph taken shortly after the new church was completed shows the spacious, simple beauty of the fifth home of the Haddonfield Methodist community. (Courtesy of Haddonfield United Methodist Church.)

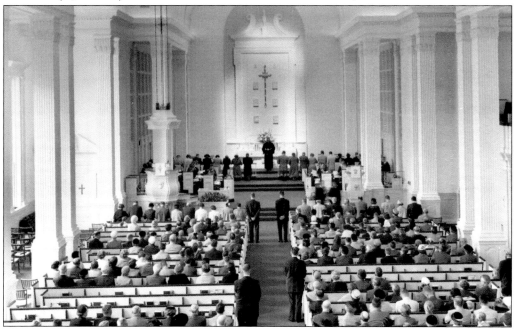

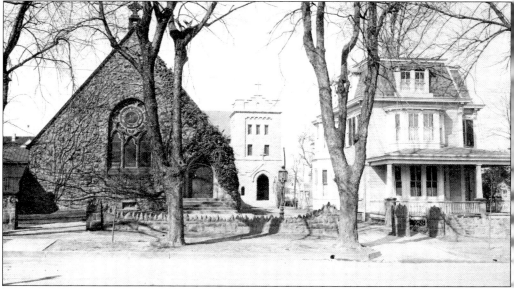

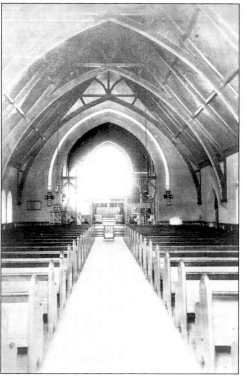

Like the Baptist and Methodist churches in Haddonfield, the Episcopal church also got its start with services in the Grove School beginning in 1841. By 1842, the congregation had purchased a lot close to the center of town on Kings Highway and built a frame church on the site. In 1891, they moved the frame church to the rear of the property and built the lovely stone church that continues to serve the congregation. The Victorian rectory seen next to the church was built in 1871 but was demolished to make way for a more modern rectory that was finished in 1961.

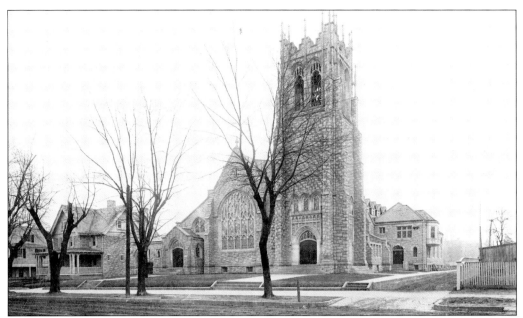

The Presbyterian church is the first that does not trace its original services to the Grove School, but instead to Fowler's Hall in 1858. It was not until 1871 that action was taken to organize a church to be called First Presbyterian Church of Haddonfield. In 1873, the congregation purchased a lot on Kings Highway East just west of Chestnut Street. The first church was a wooden structure completed in 1882. The beautiful and imposing stone church seen here was built for the congregation in 1906 by Henry D. Moore and his wife, Mary, as a memorial to their son Gilbert Henry Moore. The windows seen in the interior picture are stained glass made by the famous Tiffany Glass Company for the church. They are as beautiful and treasured today as when they were first installed.

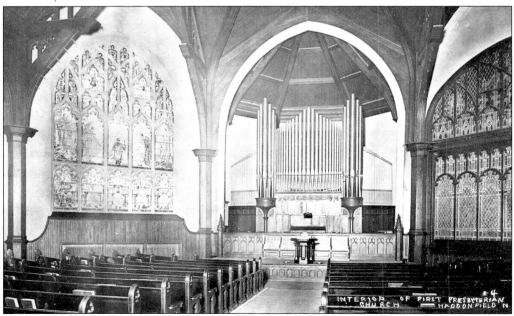

Mount Pisgah African Methodist Episcopal Church was started when black residents of Haddonfield who had traveled to Mount Pisgah African Methodist Episcopal Church in Lawnside decided in 1885 to hold services in the Grove School in Haddonfield. After two years, the congregation purchased land on Ellis Street near Cooper's Creek and erected the church. This church burned in June 2006 and is currently being rebuilt by the congregation with support from the community of Haddonfield.

Members of Mount Olivet Baptist Church began with prayer meetings in the homes of members and then moved to the Grove School in 1892. The emerging church asked for assistance from the First Baptist Church of Haddonfield, which helped the group reorganize under their sponsorship. The group purchased land at the corner of Lincoln and Douglass Avenues, and in 1894, local builder William Capern constructed the church, which continues to be used to the present day.

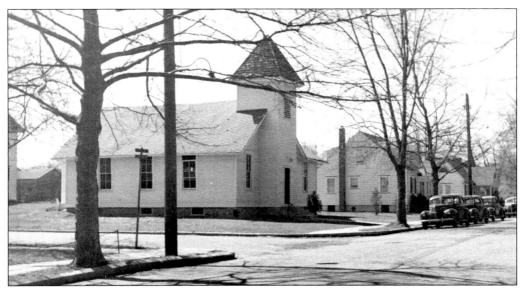

The Haddonfield Bible Church building was constructed in 1915 at the corner of Belmont Avenue and Springfield Terrace. Begun in Batesville as Christ Methodist Protestant Church, it later became Haddonfield Bible Church. In 1956, the brick church next to the original one in this picture was built, turning the 1915 church into the Sunday school. (Courtesy of Haddonfield Public Library.)

In 1927, a group met and founded the Evangelical Lutheran Church of Our Savior. After meeting in a storefront on Haddon Avenue, they quickly purchased land at the corner of Wood Lane and Wayne Avenue for a church building. They then purchased the steel framework from the Chapel of All Faiths at the 1926 Philadelphia Sesquicentennial Exposition and used it as the framework for the present brick church. (Courtesy of Lutheran Church of Our Savior.)

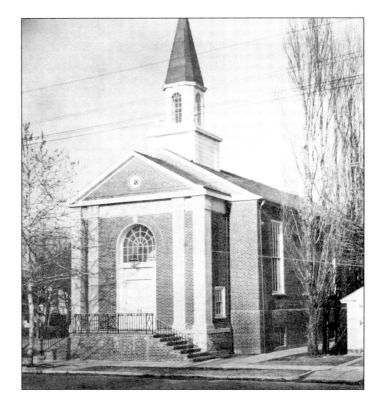

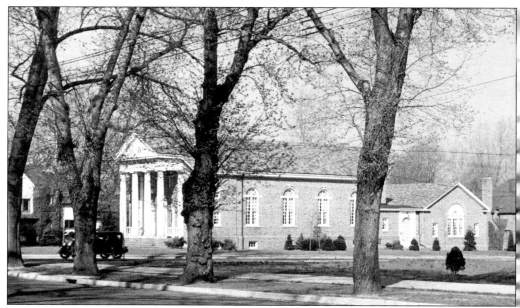

First Church of Christ Scientist, located at the corner of Kings Highway East and Sylvan Lake Avenue, was organized in 1930. In 1931, it purchased the lot on Kings Highway East and engaged George Savage as the architect for a church. Services were first held in this church on July 10, 1932, with an official dedication in June 1957 when the church was debt free. (Courtesy Haddonfield Public Library.)

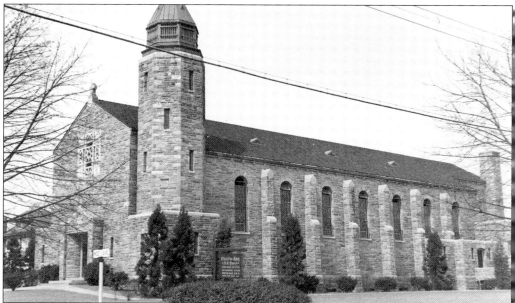

The Roman Catholic Church of Christ the King originated as an offshoot of St. Rose of Lima Church in Haddon Heights. In 1935, the Mission Church of Christ the King was made a parish with Rev. Joseph B. McIntyre as its pastor. By 1940, property was purchased on Hopkins Avenue near Wood Lane that briefly functioned as both a school and a church. The church was dedicated in November 1941.

Five

SCHOOLS

The earliest school in Haddonfield dates from the 1750s and was run by schoolmaster Richard Weeks. Probably housed in the Haddonfield Friends Meetinghouse, this school continued into the 1770s, with enrollment peaking at 57 students in 1774. Both boys and girls from ages 5 to 18 attended the school.

The Haddonfield Friends School, originally the Haddonfield Free School, built the first schoolhouse in Haddonfield in 1786. It prospered from its earliest days, especially under the dynamic leadership of Stephen Munson Day, headmaster from 1802 to 1812. Day presided over a school of 80 students, probably drawing from an area well beyond the borders of the small village of Haddonfield. Later in the 19th century, it was a boarding school for some time. Possibly in reaction to the success of the Friends school, the Grove School was built in 1809. The Grove School became the first public school in Haddonfield and in the county.

By the mid-1800s, public schooling began to be tax supported. With a steadily growing population and universal education becoming the norm, Haddonfield struggled to provide adequate schools to meet the growing needs and changing educational expectations. Not counting numerous additions and renovations, from 1870 to 1962, Haddonfield built no less than nine schools.

Many private schools have come and gone over the long history of Haddonfield. Many were small affairs with just a few students. Others such as St. John's Academy (1871–1907), a military school for most of its history with hundreds of students, and St. Mary of the Angels (1945–1971), a Catholic girls high school, were larger presences in town.

At over 200 years old, the Friends school continues today, as does Christ the King Regional School. Haddonfield is also home to schools for the developmentally disabled. The Bancroft School, now Bancroft NeuroHealth, has been here since 1883, and the Kingsway Learning Center has existed since the 1970s.

Today the Haddonfield public school system is considered to be one of the most outstanding in the state, with students consistently scoring in the high percentiles of standard tests and nearly all of its graduates going on to higher education.

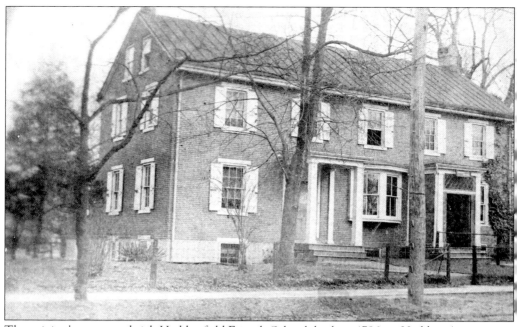

The original one-room brick Haddonfield Friends School, built in 1786 on Haddon Avenue, was incorporated into the larger brick school seen in the early-20th-century postcard. Subsequently, classrooms were added to the Quaker meetinghouse and to the main building. It now educates students from prekindergarten through eighth grade.

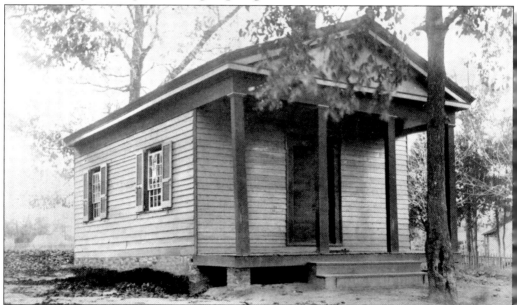

The Grove School was built in 1809 and became the first public school in the county. It was a small, rather primitive frame building on Grove Street. In addition to its early role in education, many churches in Haddonfield held their first worship services and organizational meetings at the school. After 1870, it was used as a school for African American students, closing in 1904. (Courtesy of Haddonfield United Methodist Church.)

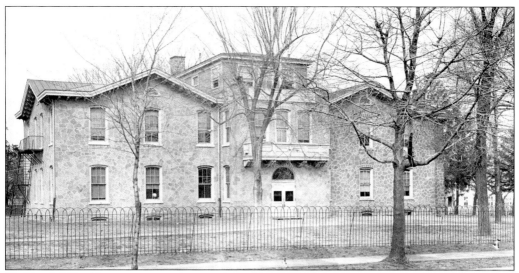

Haddonfield had long outgrown the tiny Grove School and the classrooms in the town hall when the board of education purchased property along Lincoln Avenue from the railroad company in 1868. They built a new school, the Brown building, which was completed in 1870. Two stories and 65 feet by 75 feet in size, it was considered by the standards of the time to be both beautiful and commodious. It was demolished in 1962.

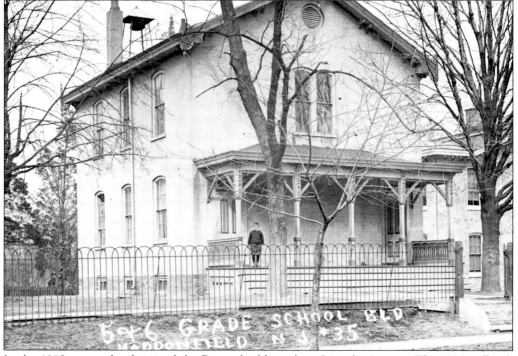

In the 1890s, two schools joined the Brown building along Lincoln Avenue. The 1890 redbrick building, designed by architect Clement Remington, is still standing and today houses the school district administrative offices. Shown in the photograph is the White building, which was built in 1894. It was razed in 1948 to make way for Central School.

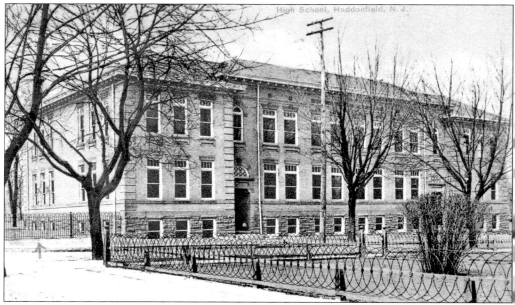

In 1908, Haddonfield built a new secondary school along Chestnut Street. By this time, universal education was the norm, curriculums were expanding, and specialized classroom spaces such as the woodworking shown below were being added. Almost immediately, this modern and large school was outgrown and was considered obsolete for modern educational needs. The population growth over the past few decades and more growth anticipated in the coming decades was one factor in the need for larger school facilities. Another major factor was Haddonfield's role as a receiving district. Since the late 1800s, students from surrounding areas, many coming via the railroad, commuted to Haddonfield for their secondary education. Converted to a junior high school, the old high school was demolished in 1962, replaced by a new middle school.

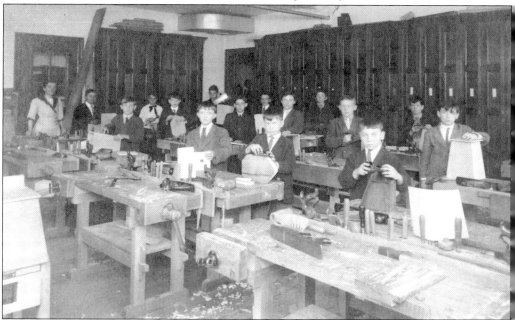

Discussion of a new high school began in earnest after World War I. Clearly there was insufficient room for a new high school at the school complex in the center of town between Lincoln Avenue and Chestnut Street. After much discussion, consideration of many sites, reviews of numerous proposed plans, and several votes of the electorate, the present site on East Kings Highway was selected. The new high school opened in 1927 and was named Haddonfield Memorial High School to honor local soldiers who served in World War I. The high school was designed to be large enough so Haddonfield could continue to receive students from the surrounding rural areas. The photograph below shows the modern cafeteria, one of the proud features of the new high school facility. (Courtesy of Haddonfield Public Library.)

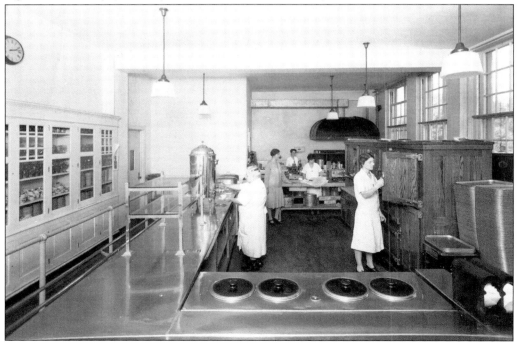

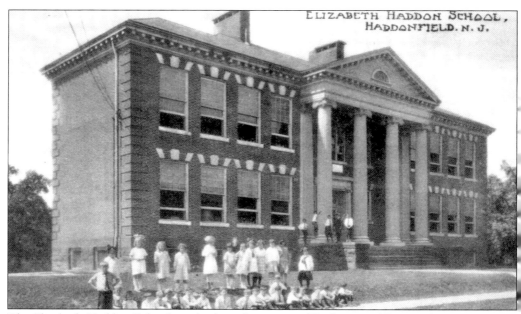

The Elizabeth Haddon School was built at the corner of Redman and Peyton Avenues in 1913. It was the first school to be built outside the school complex at Lincoln Avenue and Chestnut Street. A school in this section of town was urgently needed since most of the housing boom following the coming of the railroad was centered in west Haddonfield.

The next school to be built was Tatem School in 1922 on Glover Avenue. It was named to honor and remember J. Fithian Tatem, a community leader and a strong advocate of improved schools, who died in 1921. The need for a neighborhood school for the area east of Haddon Avenue was prompted by the Haddonfield Estates development, which was adding hundreds of homes on the former Wood farm.

Public school classes for African Americans began in 1868. In 1904, a school was built on Douglass Avenue specifically for black students. It was succeeded in 1923 by the more modern Lincoln Avenue School, partially visible in the photograph, which closed in the late 1940s when the elementary schools were integrated. (Courtesy of Haddonfield Public Library.)

Central School on Lincoln Avenue, shown on the left side of the photograph, serves much of the area south of Kings Highway. Built in 1948, it replaced the obsolete White building. Room was also needed for students from the now-closed Lincoln Avenue School. Along with the two other elementary schools, Central School has had a number of additions and major renovations throughout its history.

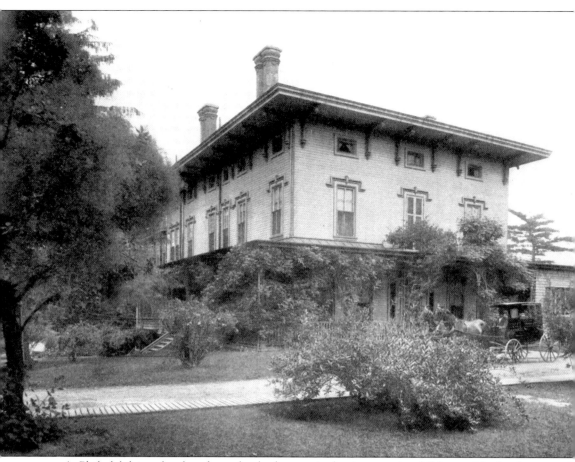

A Philadelphia schoolteacher who had a particular interest in children with developmental disabilities founded the Bancroft School in 1883. Rejecting the prevailing ideas of the day, Margaret Bancroft believed that every child could learn but special children needed special schools. A visionary educator, Bancroft was also a fiercely determined woman. Quitting her job as a public school principal, she decided to found her own school, which became one of the first schools to serve children with special needs. Bancroft selected Haddonfield, a thriving country town near Philadelphia, as a nurturing location for her pioneering school. She began in rented quarters with two pupils. The school quickly grew, and a few other locations in town soon followed. In 1892, the home housing her school was destroyed by fire. When all seemed hopeless, Charles Lippincott of Philadelphia, in exchange for the lifetime care of his daughter, purchased a large home on Kings Highway on the eastern edge of town. The school reopened at the home, known as the Lindens, in 1893. The building burned while being demolished in 1968.

In the early 20th century, numerous buildings, including another nearby large mansion, Lullworth Hall, were added to the growing school. Bancroft died in 1910, but the school has remained a leader and innovator in the ever-developing field of special education. The photograph to the right shows a speech therapist with one of the school's students. Below is an early gym class. Bancroft was a strong advocate of physical education as a part of the curriculum. Known today as Bancroft NeuroHealth, the school has greatly expanded its mission and now serves over 1,000 individuals with developmental disabilities, brain injuries, autism, and other neurological impairments. The organization now includes many locations, but the Haddonfield campus remains its headquarters. (Courtesy of Bancroft NeuroHealth.)

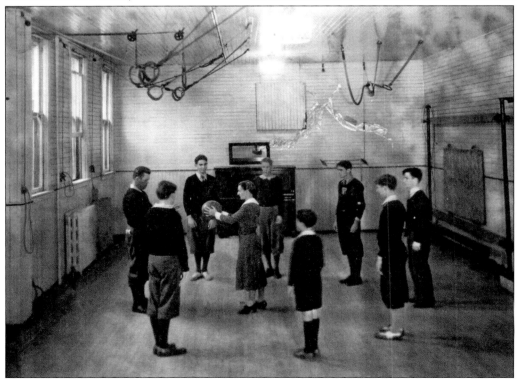

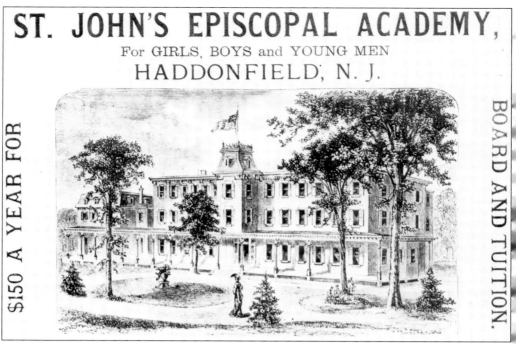

Run by Episcopal clergymen Theophilus and William Reilly, St. John's Academy opened in Haddonfield in 1871. Its first location was Mountwell, Haddonfield's first house built in 1682. In 1872, the house was destroyed by fire and the Reillys built a 175-room building on Cottage Avenue near Centre Street. In 1886, this building also burned. The school, which operated as a military academy for most of its history, closed in 1907.

Christ the King School was built on Hopkins Avenue in 1940 and opened with 150 students. For one year, the school shared the facility with the Catholic church until the new church building was finished in 1941. Additional classrooms and a gymnasium/auditorium were added in 1952. Since 1969, it has functioned as a regional school serving nearby parishes in addition to Christ the King parishioners.

Six

HOUSES AND STREET SCENES

The residential character that in many ways defines Haddonfield today arose from the way the town developed over its 300-year history. The earliest houses were centered on Kings Highway from the Cooper's Creek to about where Tanner Street is today or were farm or plantation houses like Mountwell and New Haddonfield located on the large farms surrounding the town.

Many of the earliest residences were simple wooden structures that rarely survived into the 20th century. A few were brick and have survived in larger numbers. Then as now, locations in the center of the town were highly prized. As owners became more successful, they often chose to replace modest early structures with larger, more modern homes and later with commercial buildings. The earliest houses were generally in the Colonial or Federal style.

The arrival of the railroad from Philadelphia to Atlantic City in 1853 brought the first housing developments and Victorian architectural style to the town. These were primarily located close to the railroad station south of Kings Highway on both sides of the railroad tracks, which divided the town into east and west. In the 1870s and 1880s, two different types of residents came to the town. Wealthy businessmen and successful farmers retiring to Haddonfield built large Victorian mansions along the main roads while white-collar workers bought more modest houses in the West Haddonfield development on the former Redman farm. Clement Remington, an architect, became a prominent designer of public and residential buildings in the town, and builder William Capern rose to prominence as both a builder and developer of the ever-expanding community.

The final major impetus to residential development came in the 1920s with the Delaware River Bridge, now the Benjamin Franklin Bridge. The bridge replaced the old system of ferries across the river and opened up Haddonfield as an automobile-commuter suburb. It also led to the sale of the last major farms for developments that were called Haddonfield Estates, the Gill Tract, the Birdwood tract, and Haddon Homesteads.

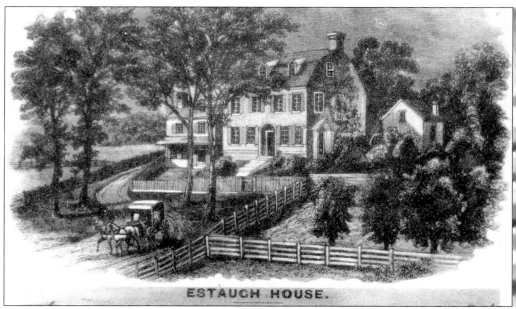

New Haddonfield, the home of John and Elizabeth Haddon Estaugh, was built in 1713 and destroyed by fire in 1842. Located at the site of what is now 201 Wood Lane, the house was built in 1713 by the Estaughs in preparation for the arrival of Elizabeth's parents, John and Elizabeth Haddon, and her sister Sarah Hopkins and her family, but it was an event that never came to pass.

The Brew House was an auxiliary kitchen for the original New Haddonfield house. It contained a still used in the early production of beer and hard cider for the farm as well as for the production of medicines. The Estaughs were respected for their knowledge of early medicines. A second floor was added as a place to stay for workmen employed in rebuilding the house after the 1842 fire.

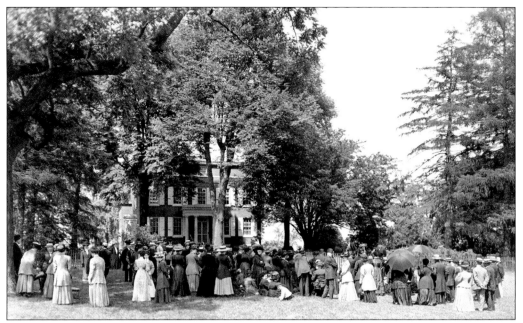

Following the fire, a new house was built on the foundations of the original. Known as the Wood farm, it continued to be respected for its connection with Elizabeth Haddon Estaugh and the history of the town. In this picture, the Friends Historical Society is visiting the property on a pilgrimage to historic sites about 1910.

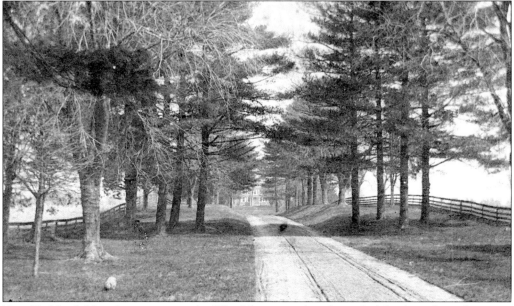

New Haddonfield and its successor, the Wood farm, stood at the end of this long drive that went from the house to the Ferry Road, today's Haddon Avenue. In this picture, the house presided over a large farm that grew crops and raised animals for sale in the markets of Haddonfield, Camden, and Philadelphia. It became a housing development called Haddonfield Estates in the 1920s.

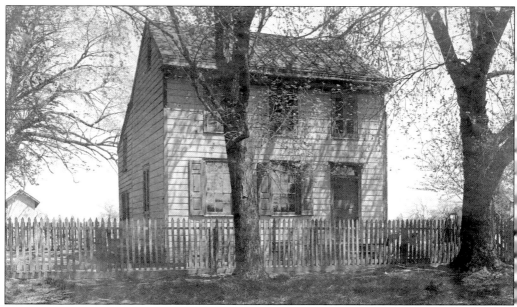

The Wood farm, like most other farms, had small residences usually along the edges of the property that were used as tenant houses for laborers who worked on the farm. This was one of at least five that housed workers for the farm. Maps show two houses on Haddon Avenue, one on Grove Street, and two on Maple Avenue. This house probably stood on Maple Avenue at the corner of Grove Street.

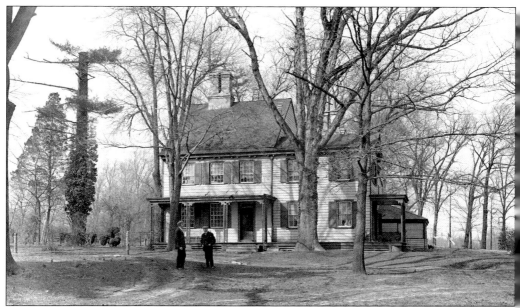

Birdwood was built about 1794 for William Estaugh Hopkins by his father, John Estaugh Hopkins. The house is particularly notable because it was where William Parker Foulke noticed a dinosaur bone being used as an umbrella stand. Realizing its importance, he asked for permission to look for more specimens on the farm, leading to the discovery of the Hadrosaurus foulkii in 1858. It was also at one time the home of Gov. Alfred E. Driscoll.

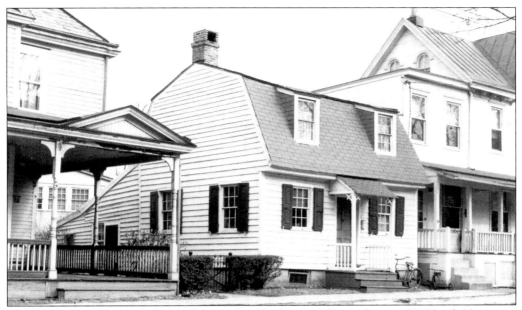

The Samuel Mickle house, one of the earliest buildings still standing in Haddonfield, is seen here on Ellis Street near Centre Street, its second location in town. Having started out next to the Indian King Tavern in the early 1700s, it was moved in 1965 for a third time to the grounds of the historical society next to Greenfield Hall. It is an important example of early construction methods and materials. (Courtesy of Haddonfield Public Library.)

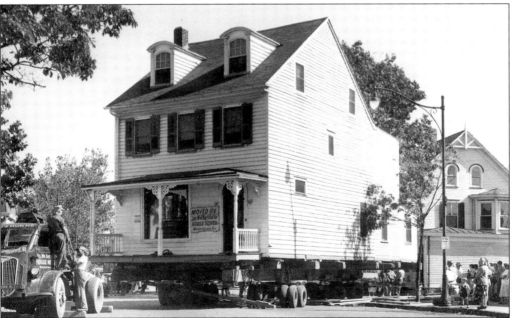

Houses and outbuildings have been moved for many years. In the early years, before wires, gas lines, and other utilities, moving a house was more straightforward than the house in this 1949 picture. It is being moved from 208 Kings Highway East to 8 Roberts Avenue. Known as the Fortiner House, it is a good example of a Federal-style house.

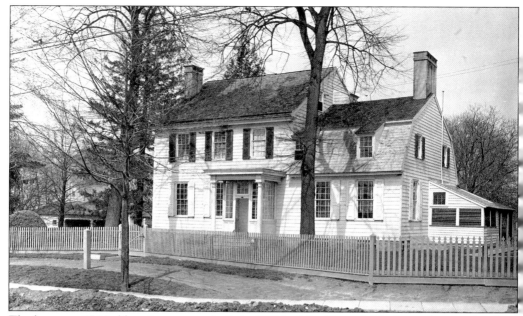

The house at 65 Haddon Avenue was built in 1799 by John Estaugh Hopkins, the grandnephew of Elizabeth Haddon Estaugh, when he retired from running the New Haddonfield farm. From this house, he continued as an active townsman, involved in the Friends meeting and school, the library company, and township government.

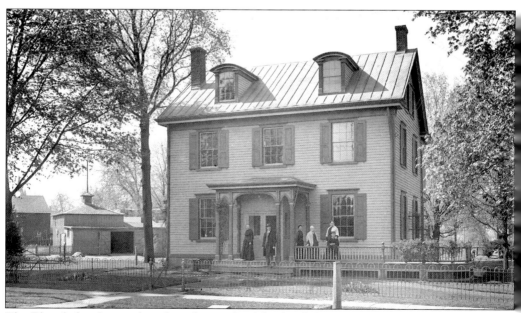

The Rhoads family is gathered on the porch of the family home at 56 Haddon Avenue. Charles Rhoads was a respected town leader and member of the Friends meeting who is credited with being responsible for the town voting down the sale of alcohol beginning in 1873, a tradition that continues today. This house, which became a Quaker retirement home known as the Estaugh, was ultimately demolished and replaced by an office building.

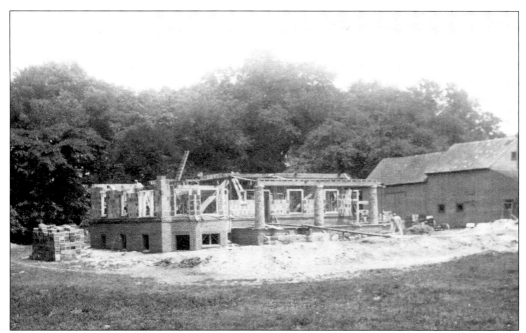

Samuel Nicholson Rhoads built a home at 81 Haddon Avenue. He was the son of Charles and nephew of Sarah and Rebecca Nicholson, who lived in the Hopkins house next door. In 1912, Samuel, who had grown up across the street from his aunts, asked Sarah and Rebecca if he might build a modern house on the land adjoining their home. They agreed, and on the spacious lot, he built a modern stucco bungalow. The house had a beautiful pond in front where the old stream that crossed under Haddon Avenue at the intersection of Tanner Street and Haddon came out onto his property.

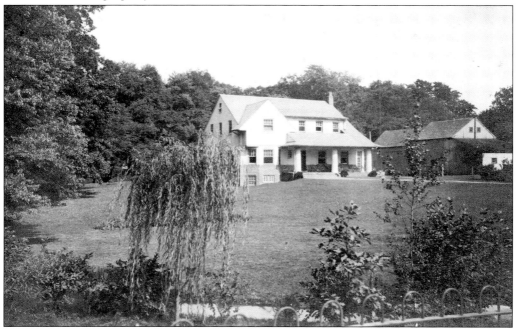

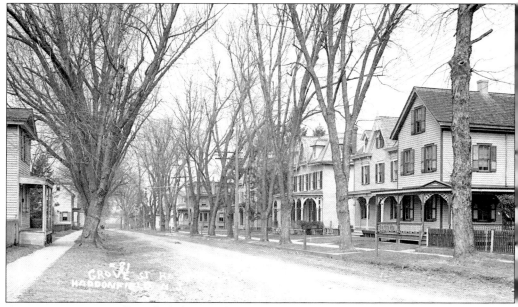

Grove Street, originally called the Landing Road because there was a boat landing where it crossed Cooper's Creek, developed north from Kings Highway at a rapid pace in the Victorian era. Originally populated by a few modest vernacular houses, larger Victorians on small and medium-sized lots filled in as far as Lake Street in the late 1800s. The street, like most, remained unpaved in the early 20th century. (Courtesy of Anne and Boyd Hitchner.)

Samuel Abbot Willits, who owned Willits Coal and Lumber Company on Tanner Street, built a spacious, Second Empire, mansard-roofed Victorian home at 49 Grove Street for his family. The Willits were very active members of the Haddonfield Friends Meeting and built the home in part because of its proximity to the meetinghouse, which was just down the lane opposite this house.

Lincoln Avenue, originally named Haddon Avenue, was the area of an early proposed housing development. Land just east of the railroad was bought, laid out in blocks, and advertised for sale, but the company failed without actually building any houses. By the dawn of the 20th century, the street name was changed to Lincoln Avenue, and the block between Chestnut and Centre Streets was fully developed. (Courtesy of Anne and Boyd Hitchner.)

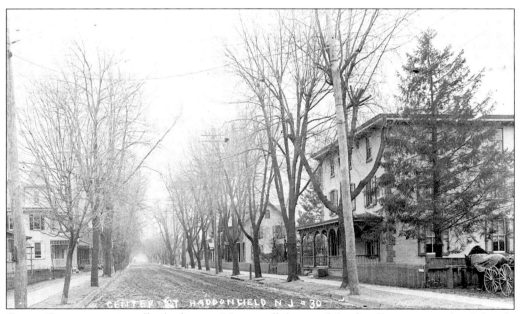

Centre Street was originally the lane to Mountwell, home of the first European settler. It briefly became Clement Street and ultimately Centre Street because it went to Centre Township. Since it was near Kings Highway and the railroad, simple workmen's houses and a few larger, more ornate Victorians were built on it beginning in the second half of the 19th century. (Courtesy of Anne and Boyd Hitchner.)

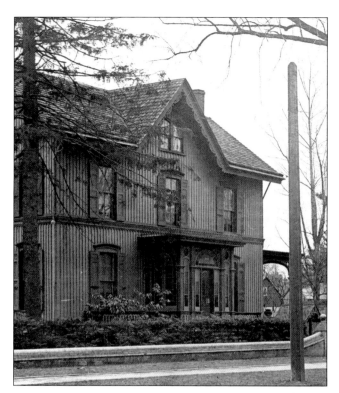

Kings Highway in the late 19th and early 20th century was a popular place for residents of all economic levels to live. This house was the home of Edward Drinker Cope, a noted 19th-century paleontologist, who was one of the two principals in a 19th-century rivalry that became known as the dinosaur wars. The house was demolished when the Haddonfield Borough Hall was built. (Courtesy of Haddonfield Police Department.)

Kings Highway, also called Main Street at various points in its history, had a mix of housing stock, including the modest stucco house of an early saddler named William Griscom standing next to a late-19th-century brick townhouse. The old buttonwood trees, which stood at the time of the American Revolution, were treasured and marked with signs relating the historic events they had witnessed.

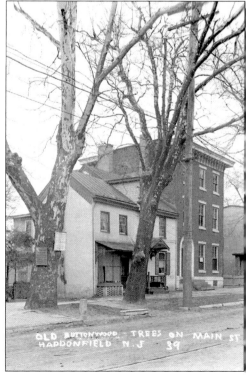

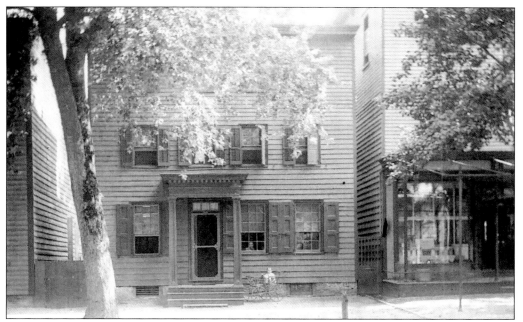

The extensive changes in the center of town are shown in this picture of 204 Kings Highway East. At the time this photograph was taken, the house was the home of the Harris family. Later demolished, part of the CVS drugstore occupies the site of the house today. The commercial building seen to the right still stands at the corner of Kings Court. (Courtesy of Don Harris.)

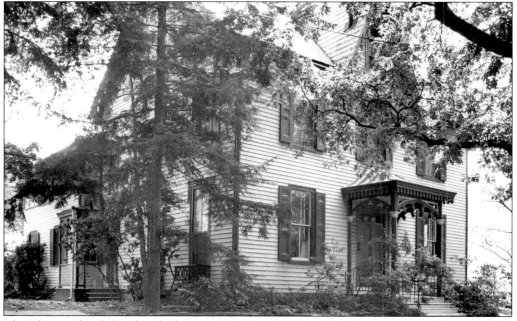

The Clement family lived in the home at 264 Kings Highway East for generations. The rear of the house is part of an earlier 18th-century home. In 1854, Judge John Clement had the front portion of the old house moved to Potter Street and a modern Gothic Victorian home built in front of the old Colonial rear. The property remained a family residence until the late 20th century.

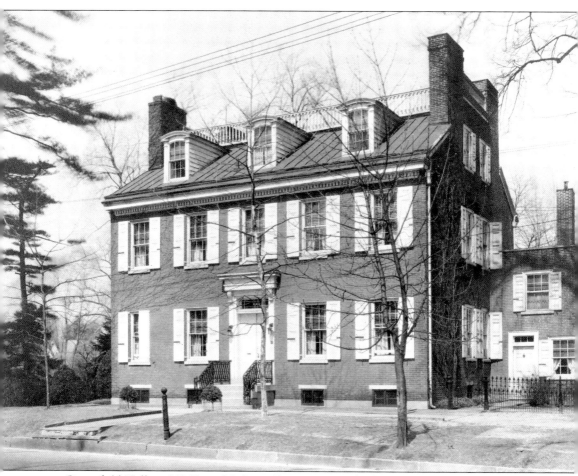

Greenfield Hall, at 343 Kings Highway East, serves as the headquarters of the Historical Society of Haddonfield. The house that stands today is the third Gill house on the property. It was built in 1841 by John Gill IV in anticipation of his marriage to Elizabeth French of Moorestown. During the American Revolution, Count Carl Von Donop spent the night before the battle of Red Bank in the earlier Gill house while his troops encamped around it. Von Donop was killed in the battle the next day. Seen here, it is the home of Harry and Sylvia Bauer, who sold the house to the historical society for its headquarters in 1960. Today it functions as a museum housing collections of Haddonfield history that have been donated to the society since its incorporation in 1914. The society houses its extensive library collections in the adjacent Samuel Mickle house, moved to the site from Ellis Street.

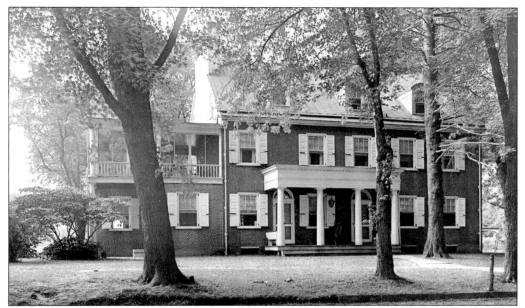

In 1816, John Roberts, owner of the Indian King Tavern, built the house on Kings Highway East opposite Greenfield Hall. Built as a farmhouse, it was renovated and enlarged into a brick mansion in both the 19th and 20th centuries. The house has served as the home of prominent residents, including David Stern, who gave Isadore Feinstein, later known as I. F. Stone, his first newspaper job.

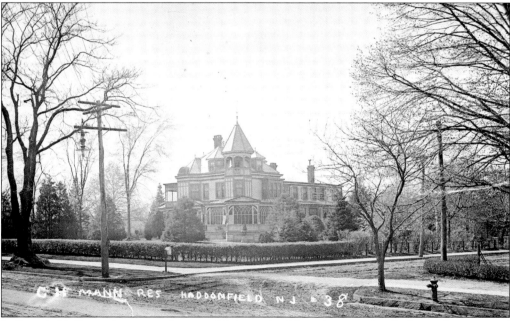

Lullworth Hall was the name given to this imposing Victorian mansion built on the corner of Kings Highway East and Hopkins Lane by Charles Mann about 1886. This was the first house in Haddonfield to have electric lights. It became part of the Bancroft School complex in 1919 and serves today as the headquarters building for Bancroft NeuroHealth.

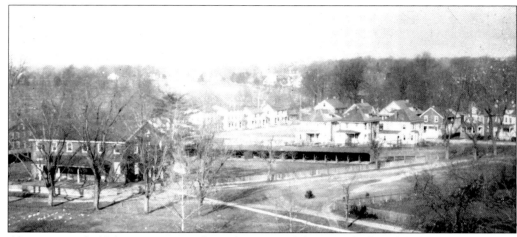

Above, an early-20th-century view from the tower of the town hall and firehouse on Haddon Avenue looks toward the Friends meeting on Friends Avenue, Lake Street, and houses on Colonial Avenue. Behind the meeting are horse sheds used by Quakers attending services. On Lake Street, the Wingender pottery and early houses can be seen. Colonial Avenue, seen behind the horse sheds, and the view down Colonial Avenue from Willits Lane toward Lake Street, below, shows several foursquare houses built on the street, primarily in the early 1900s. (Courtesy of Anne and Boyd Hitchner.)

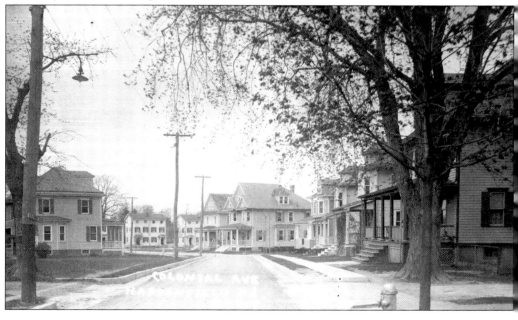

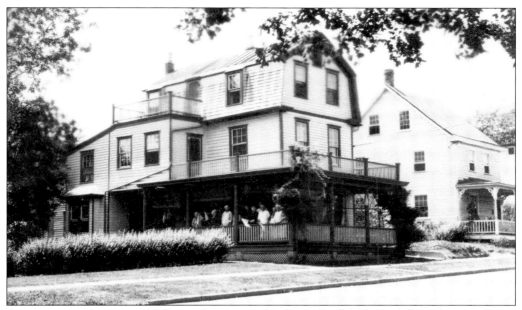

An interesting house at 124 Potter Street was the Anna Scull Memorial Rest Cottage. It was founded about 1906 by local resident Caroline Scull Haines, who remodeled and enlarged the house so it could serve as a place for women who worked in manufacturing jobs in the cities to come to the country for a week of rest, relaxation, and recuperation.

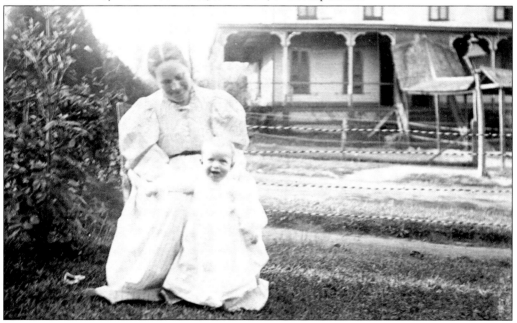

Eleanor Reilly Trend, seen here with her baby, is sitting in front of a twin house on Lakeview Avenue that was originally used as a dormitory for the schools run by her family. St. Johns Military Academy for boys and St. Agnes Hall for girls were private Episcopal boarding schools. A number of houses on Lakeview Avenue were originally constructed as dormitories for the boarding schools.

William Capern was an important builder in Haddonfield in the late 19th and early 20th centuries. Over many years, he worked as a major builder on Washington Avenue. The brochure touting Haddonfield "the Beautiful" was issued to boost sales of his early-20th-century homes in a section he called Colonial Ridge. It ran from Mountwell Avenue to Jefferson Avenue along Washington Avenue. The postcard below shows some of his earlier Victorian houses on the 300 block of Washington Avenue. Capern built both custom houses for many prominent residents and for architect Clement Remington, and foursquare homes for other buyers on streets like Chestnut Street, Estaugh Avenue, and Colonial Avenue.

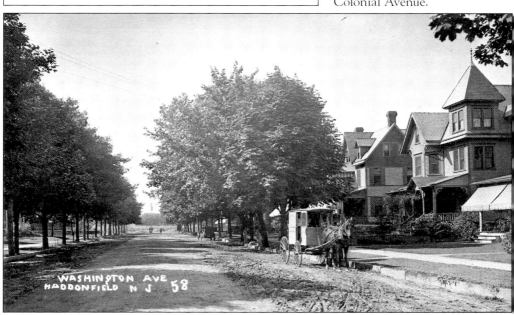

In the early 20th century, the foursquare house became a predominant architectural style in Haddonfield and the vicinity. Foursquare houses had four fairly equally sized rooms on both the first and second floors, and both the rooms and overall houses were essentially square in shape. Although there are differences in architectural embellishments among the various houses seen in the first block of Linden Avenue, most were built by local builder William Capern. The foursquare seen below, located at 324 Warwick Avenue, was the boyhood home of Gov. Alfred E. Driscoll.

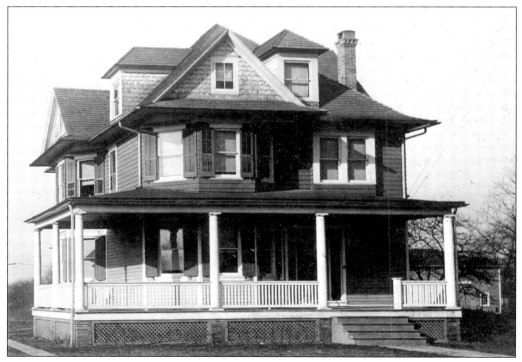

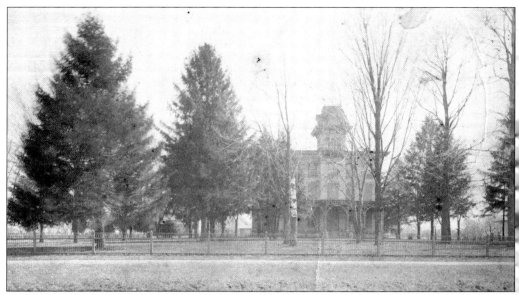

The mansion seen in these pictures was built as a family residence by John A. J. Sheets in 1874. The house stood at 150 Kings Highway West, near the intersection of Chews Landing Road. It included approximately six and a half acres of land surrounding the home and was the largest, most grand Victorian mansion that ever stood in Haddonfield. This house was purchased in 1894 by local magnate Henry D. Moore, who modernized the house with Colonial Revival elements like the rounded posts and turrets on the front porch. The property had numerous outbuildings, including a schoolhouse, children's playhouse, and barns. When a buyer for the property could not be found about 1960, this house and the house at 200 Warwick Road were both demolished to make way for the development of Moore Lane.

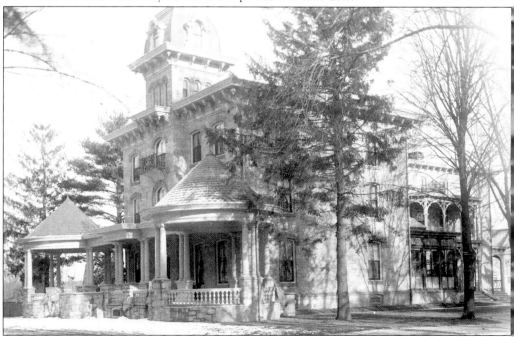

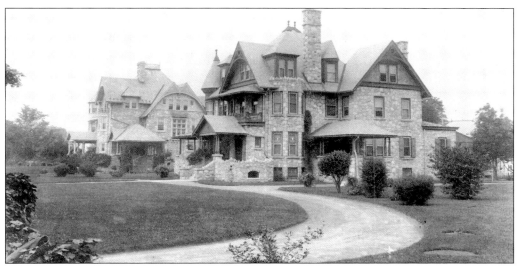

The children of Henry D. Moore and his wife, Mary, lived in homes equal in stature to the one in which they had been raised. The larger stone house on the left in the picture above was the home of William G. Moore, who bought it in 1901. Located at 257 and 241 Kings Highway West, the two houses had originally been built for a brother and sister, Robert D. Sorver and Kate Sorver Hillman. The house below originally stood at 350 Kings Highway West and was the home of Robert T. Moore. Once set in a gracious estatelike surrounding, the house now has a Knolltop Lane address, and all the houses on Knolltop were built on the original property of the house. (Above, courtesy of Anne and Boyd Hitchner.)

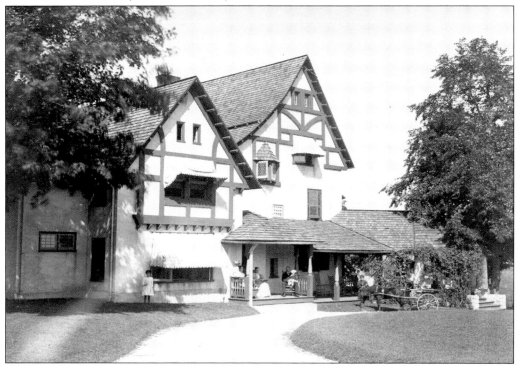

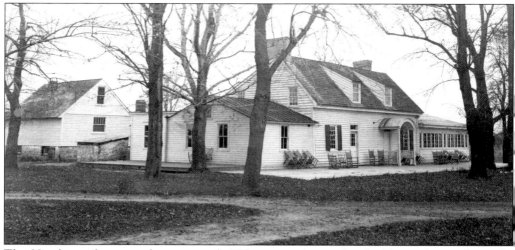

The Hinchman homestead was an early-18th-century home that had been the residence for the Hinchman family farm, located on the north side of Kings Highway West from about Avondale Avenue to Hopkins Avenue in Haddon Township. In the early 20th century, the house and land were leased to the Haddonfield Country Club, which offered golf and tennis on the site until 1921 when Tavistock Country Club was created outside the borough limits in order to avoid the blue laws against playing golf on Sunday. Much of the land that had been the country club was divided into lots, renamed Haddon Homesteads, and offered for sale by Carter-Fredericks Company.

A PLEDGE

HADDON HOMESTEADS is forever dedicated to that class of citizens who desire to build their "home sweet home" in a community composed of cultured, refined people, where they can, while enjoying all of the advantages of country life, be within easy access of a great city.

Our idea in founding HADDON HOMESTEADS is to make it a suburb where no buildings of any kind can be erected except for residential purposes.

Private garages may be built but they must be in keeping with the type of surrounding properties.

The building restrictions at HADDON HOMESTEADS are of such a nature that no one who buys a homesite need have any fear that surrounding property will be in any way objectionable.

Fully realizing our responsibility as developers of HADDON HOMESTEADS we hereby pledge ourselves to continue the policy we have laid down of making this tract the finest and most exclusive in southern New Jersey.

CARTER-FREDERICKS COMPANY

GEO. E. FREDERICKS, President HOWARD L. CARTER, Secretary & Treasurer

OWN YOUR HOME WHERE
HISTORY and MODERN DAYS MEET
Haddonfield Estates

Our property, consisting of 135 acres of land is the old, Historical homesite of Elizabeth Haddon, one of the Pioneer settlers of Haddonfield.

Every care and thought for the comfort and convenience of Homebuyers has been taken care of. Pure water, sewerage, sidewalks, curbing, electricity etc., now on property.

LARGE LOTS 50 X 145 FEET
Buy your lots and build or select one of our houses
WE WILL FINANCE
HADDONFIELD ESTATES CO.
EARL R. LIPPINCOTT

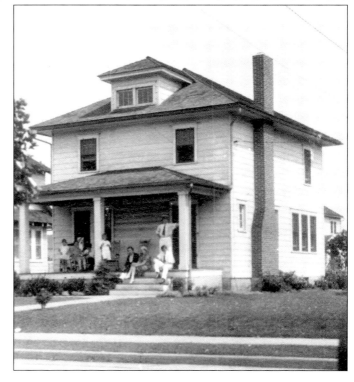

Haddonfield Estates was the name conferred by developer Earl R. Lippincott on the land that had originally been New Haddonfield, later the Wood farm. The development included the streets running from Hopkins Avenue to Maple Avenue and from Haddon Avenue to Grove Street. Samuel Wood, the last of the family to farm the property, reserved three acres between Merion and Hawthorne Avenues on Wood Lane where his family farmhouse stood. A sales office was opened at 301 Haddon Avenue, and lots were offered for sale. The house seen at right was owned by the Huth family and was located at 128 Marne Avenue. (Courtesy of Dr. Edward J. Huth.)

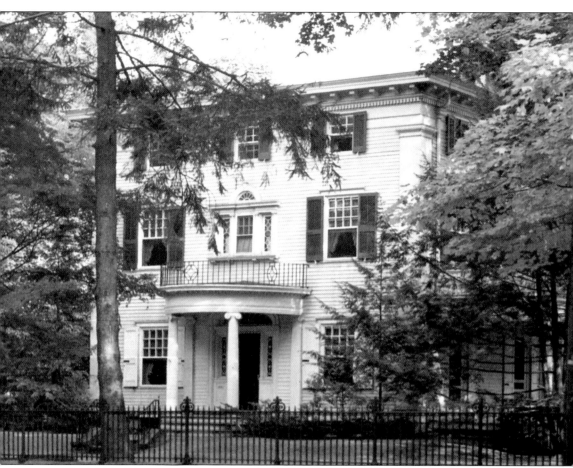

The McNeill house, seen here as it stood at 134 Kings Highway West, was an Italianate Victorian house that had some Colonial elements added in the Colonial Revival era of the early 20th century. A beautiful and gracious home, it proved to be the spark that ignited the movement for historic preservation in Haddonfield. The house was demolished 1967 over the objections of many residents and organizations in the community. Its demolition brought a realization to the town that it had no legal tools to prevent the demolition of the historic fabric of the town. Through referendum, against the wishes of the commissioners at the time, a historic district ordinance was enacted to protect the core of the town against demolition or inappropriate alterations to historic structures in the historic district. (Courtesy of Haddonfield Public Library.)

Seven
People and Lifestyles

As with any community, it is the people, the way they live, the things they value, and their events and traditions that give richness and texture to any town. Haddonfield has been fortunate over its long history to have always had people who cared about the town and were willing to be active participants in making it the kind of place where people would want to live. The community has benefited from the knowledge, wisdom, and perspective the older generations had to share.

Over the period from the late 19th century to the late 20th century, the development in the town led to significant changes in the lifestyles of its residents. Originally the open farm fields that surrounded the town allowed for leisure activities like hunting, horseback riding, sleigh riding, and large group picnics. The ponds were active sites of boating and swimming. Youngsters felt free to simply explore the woods and fields and go sledding and bike riding on their own. Once in high school they might take up a sport like field hockey, football, or basketball. As young adults they could play on cricket or baseball teams through local clubs or churches. Things were generally much less organized and more readily available due to the lack of development in the town.

In the mid- to late 20th century, the town became fully developed, resulting in less opportunity for spontaneous fun. Sports for young people have become totally organized. No longer do children simply go to a field and start an impromptu ball game. Weather changes have significantly altered winter amusements since there is rarely enough snow for sledding or ice thick enough for skating. The lifestyle of the community and its residents has changed dramatically.

Reilly's Woods, located at the foot of the Centre Street where a small stream passed under the railroad running to the South Branch of the Cooper's Creek, was a popular location for hiking and picnics. In 1913, thanks to the effort of the Haddon Fortnightly, the stream was dammed with cobblestones taken from pedestrian crossings on Kings Highway when the road was paved. This created a natural swimming pool for the town that was named Mountwell Pool.

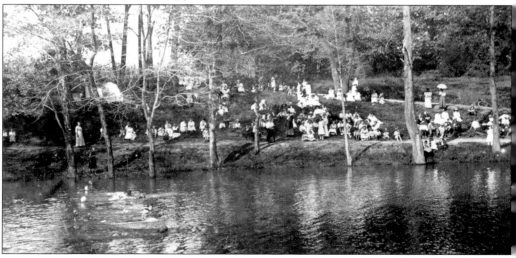

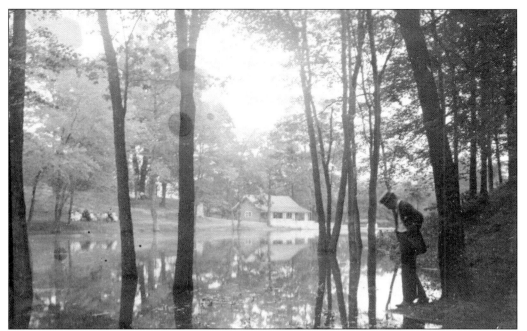

Mountwell Pool was an instant success as a community swimming pool. The Haddonfield Civic Association raised money to build a bathhouse, which is seen in this early picture. Also visible are the natural edges of the original pool, a result of simply damming the stream.

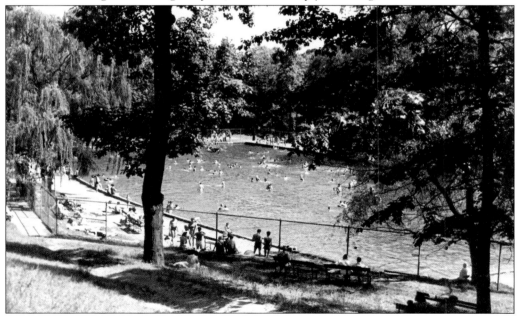

Mountwell Pool is seen after 1937 when a large cement pool was laid by Camden County Park System to whom the borough had deeded the property in 1928. Years after the county park system had closed the pool, the property was deeded back to the Borough of Haddonfield. Today only the overgrown ruins of the pool are visible in the woods. (Courtesy of Haddonfield Public Library.)

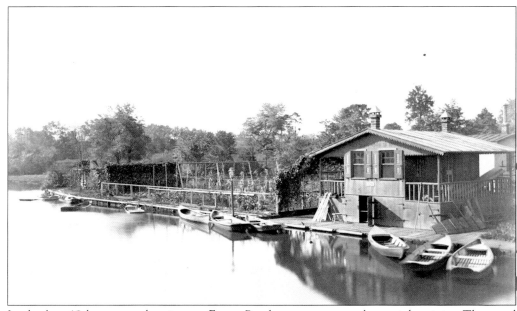

In the late 19th century, boating on Evans Pond was a very popular social activity. The pond was significantly larger than it is today due to a higher dam. People could rent boats from the boathouses seen in the 1894 photograph above and enjoy a spin around the pond. They were located just east of Ellis Street where it crosses Cooper's Creek today. The serenity of the pond is seen in the 1891 image below of a man paddling toward the mill on Evans Pond. There are many newspaper reports of grand boat parades on the pond as well as Fourth of July fireworks, which were set off on the Cherry Hill side of the pond with throngs of spectators watching from the Haddonfield shore.

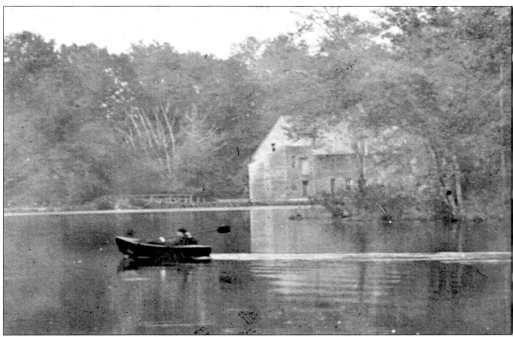

Hunting, gunning, and gun clubs were very popular in Haddonfield in the late 19th and early 20th centuries until the town no longer had the open farm fields and woods surrounding the town for these activities. Ephriam T. Gill (left) and his dog Little Jake are shown with his hunting buddy W. H. Corson and his dog Bull. Gill owned Haddon Farms on Warwick Road, which offered acres of woodland appropriate for hunting. Most young boys could not wait until they were old enough to receive their own rifle and hunt small game. Robert (left) and Ben Wood are shown preparing their guns for a day of hunting in the 1890s.

Sledding has always been a popular winter pastime, as seen in these two pictures. Robert Wood (above) was ready for fun in the 1890s with his sled and knickers on a lawn covered with snow. In the 1960s, many families are seen sledding on Centre Street in Reilly's Woods (below). At the time of this picture, the borough generally did not plow the hill on Washington Avenue or this part of the Centre Street hill so that families could go sledding, a practice that is no longer observed. Sledding in the late 20th and early 21st century seems an infrequent occurrence due to an apparent decrease in winter snowfall. Children rarely receive sleds and skates as gifts, unlike in earlier times.

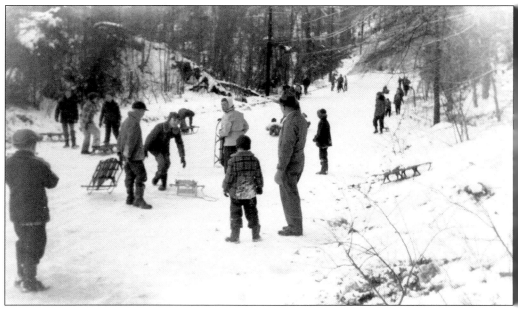

Skating on Evans Pond in 1938 was clearly a popular and safe pastime. Early newspapers frequently carried reports of great skating parties on Evans and Hopkins Ponds, as well as reporting an occasional drowning or near drowning as the result of skating on unsafe ice. A happy Bill Stevens is shown enjoying a day of skating. (Courtesy of Helen Stevens Mountney.)

Ponds were not always necessary for outdoor fun, as seen in this picture from Joyce Hill of her father and his siblings skating and sweeping the ice on the side of the family home on Walnut Street. (Courtesy of Joyce Hillman Hill.)

James Stretch, mounted on the horse on the left, was an avid horseman all his life. He was the local undertaker whose love of horses led to his operating a livery stable as well. In this picture, he and three friends were enjoying a pleasant ride along the dirt roads of town, with everyone dressed appropriately for the event.

Even into the mid-20th century, a number of people still kept ponies in town for their children to ride. In this 1906 picture, Robert Moore Tatem is seen riding his pony around the neighborhood. He was one of the sons of J. Fithian Tatem, for whom an elementary school was named.

Bicycles became a popular source of both exercise and social life in the late 1800s. There were frequent references to social events involving cycling parties in newspapers from the late 19th and early 20th centuries. These two early tricycles are being enjoyed by Mary and Joseph Tatem in the backyard of their house at 35 Grove Street.

Bicycles have always been a wonderful source of independence, socialization, and exercise for young children. In this picture from about 1931, from left to right, Jimmy Stretch, Helen Marie Stiles, Albert D. Stiles Jr., Elinor Stiles, and two unidentified friends are seen by the house at 108 Washington Avenue prior to a cold-weather ride on their bicycles and tricycle. (Courtesy of Helen Stiles Peterson.)

Both cricket and tennis were extremely popular sports beginning in the late 19th century. The cricket club in this picture was located on Haddon Avenue at Harding Avenue. Cricket matches, among various town teams from New Jersey and Pennsylvania, were once popular community events. The windmill was located atop the barn behind the house at 242 Kings Highway East, site of the present borough hall. (Courtesy of Haddonfield Public Library.)

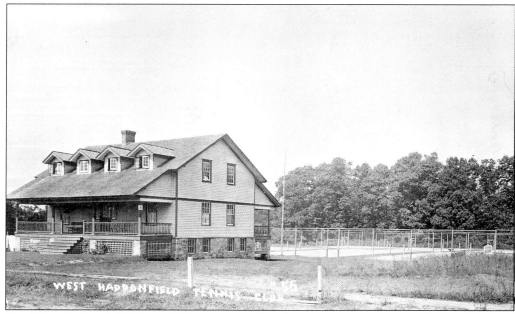

The West Haddonfield Tennis Club was located on the property now occupied by the Elizabeth Haddon School at Redman and Avondale Avenues. The club continued to operate even after the opening of the school, initially sharing the block with the newly built school. The building seen here later became the kindergarten classroom for the school once the tennis club was closed.

Ben (left) and Robert Wood pose with their tennis racquets in the rear of the family home at 109 Kings Highway West. In addition to tennis, the boys enjoyed most outdoor activities of the late 1800s, including shooting, boating, camping, hiking, biking, and gardening. They enjoyed an active outdoor lifestyle that predominated among boys of their generation.

Two young men are shown playing tennis on the Presbyterian Athletic Association tennis court, which was located along Chestnut Street on the site of the church parking lot today. Sports were an important adjunct to church functions, and the Presbyterian church fielded a baseball team as well as offering tennis to its members.

Tavistock Country Club and the borough of Tavistock were incorporated in 1921 as a result of Haddonfield's blue laws against the playing of golf on Sundays rather than because of its ban on liquor, as is often suggested. About 1918, Frank W. Middleton, an avid golfer and member of Haddonfield Country Club, purchased the Gill family farm from Mary Gill Hopkins. Hopkins, the daughter of William H. Gill, had inherited the property from her father and with her husband, Johns Hopkins, used the property as a summer home. They built a new summer residence on the site in 1888 and named it Tavistock. Widowed before the birth of her second son, she continued to live in Philadelphia but kept Tavistock as a weekend and summer home for herself and her sons, Johns and William. By 1918, in failing health and with her sons overseas in World War I, she sold Tavistock to Middleton. When the owner of the land rented by Haddonfield Country Club requested a large increase in rent, Middleton stepped in with the Tavistock property and the old club closed.

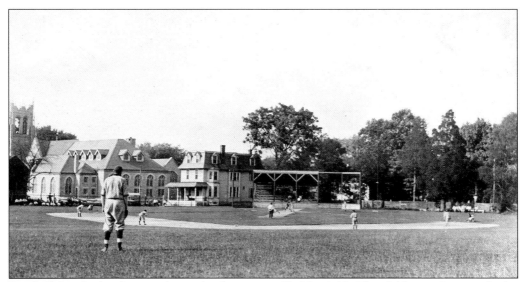

Baseball has had a long and popular history in Haddonfield. The field seen here with the extensive grandstand is located behind the Presbyterian church on Kings Highway. The church sponsored a team that played in the Presbyterian League in the early 20th century. Another baseball field was located on Haddon Avenue at East Euclid Avenue, before East Euclid Avenue was built. The high school also fielded its own team.

Little League gained prominence in town in the mid-20th century, offering organized baseball to younger boys. Gov. Alfred E. Driscoll, a Haddonfield resident, is seen here throwing out the first ball of the 1950 season at the Little League fields on Ellis Street, the first year the town had Little League teams.

Haddonfield did not escape the effects of the military conflicts that affected the entire nation. Norman Nicholson, a first class private stationed in the camp post office at Camp Dix, is seen in this June 1918 picture taken at 45 West End Avenue. He came down with influenza in the great 1918 epidemic and died, one of four Haddonfield casualties of World War I. (Courtesy of Dianne Hartel Snodgrass.)

A group of young men from the town gather on the front steps of Haddonfield Borough Hall in 1942 to await their departure for military service during World War II. Large numbers of young men and women from Haddonfield joined the military while local organizations worked to support the troops on the home front. (Courtesy of Louis Goddard and the estate of William Cope.)

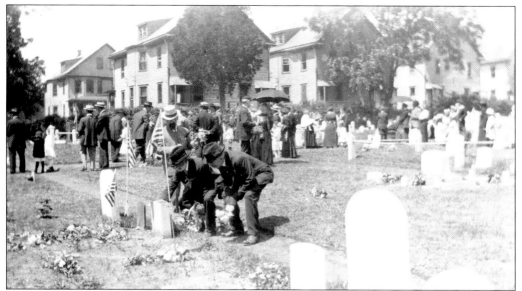

Memorial Day was once a major event in town. Large parades wended through the town, ending up in the Methodist cemetery seen here where there were speeches, gun salutes, and music. In this picture from the early 20th century, the two elderly gentlemen laying flowers are Civil War veterans and members of the Grand Army of the Republic.

The end of World War I, the war to end all wars, was cause for a great celebration in Haddonfield in 1919. Led by World War I and Civil War veterans, the parade marched through town to the grateful applause of residents of Haddonfield and surrounding areas. It included floats made by community groups as well as representatives from most local organizations.

The Fourth of July parade has been a major event in Haddonfield and the vicinity for many years. The parade includes local organizations, neighborhoods, and residents, along with bands, police, the fire department, and antique cars. It brings large crowds to the downtown area for a day of celebration and fireworks. Children look forward to riding their decorated bicycles down Kings Highway for judging followed by prizes and games at Haddonfield Memorial High School. Another great tradition of the parade is the neighborhood groups and their commentary. Whether the topic is controversial or simply timely, the neighborhoods can be counted on to produce clever and pointed signs, floats, and costumes that take on local issues.

Neighborhood political commentary found in the parade is exemplified by this float in a 1960s parade saying, "Let's Keep Haddonfield Colonial—Depress the Line." Original plans called for the train through Haddonfield to be elevated as it was in other towns. Haddonfield residents believed that an elevated train would severely affect the Colonial appearance and fabric of the town. The parade offered them the opportunity to make their feelings known.

Another annual tradition of the Fourth of July parade is the distribution of American flags by members of American Legion Post 38. The lead of the parade is always taken by a color guard followed by the members of the legion handing out free flags to those gathered along the street to watch the parade.

Although the Fourth of July parade is the largest one in town, the Halloween parade, held the night before Halloween, is very much anticipated and enjoyed by the children of Haddonfield. In the dark of night, they march down the middle of Kings Highway from the Presbyterian church to the high school, showing off their costumes to neighbors and parents who come to watch.

Before the coming of the Cherry Hill Mall and other malls, Haddonfield was a major shopping destination for southern New Jersey. Christmas shopping in particular was a major event for the town. Santa came to town in a horse-drawn wagon on the Saturday after Thanksgiving to obviously large crowds who were getting an early start on their Christmas shopping.

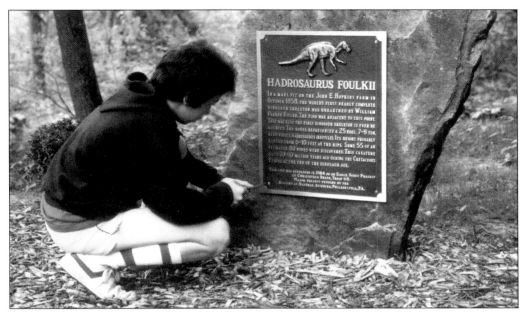

In 1984, Boy Scout Chris Brees's Eagle Scout project was to mark the site where the famous Hadrosaurus foulkii was found. Working with the Academy of Natural Sciences in Philadelphia, he arranged for a bronze plaque to be installed on Maple Avenue near where the dinosaur bones were found in 1858. In 1994, the site was further honored as a national historic landmark. (Courtesy of Linda and Butch Brees.)

Local sculptor John Giannotti is shown in his studio working on his sculpture of Hadrosaurus foulkii. A plan initiated by the Haddonfield Garden Club evolved into a committee called HATCH (Haddonfield Acts to Create Hadrosaurus) that raised funds to create and install a dinosaur sculpture at Lantern Lane and Kings Highway. The project was successfully completed in October 2003. (Courtesy of Hoag Levins.)

Children from the Wood family were dressed appropriately for the Fourth of July holiday in 1925. Below, young Evan Rhoads is seen at the age of three helping his family in the garden with his little wheelbarrow.

The Harris children are seen playing on a homemade backyard seesaw in the rear of the family house at 204 Kings Highway East in the early 20th century. In their day, there were no town playgrounds, so families made their own play equipment like swings attached to backyard tree branches. (Courtesy of Don Harris.)

Elephant ears, a favorite Victorian garden plant, made a fun hiding place for these young children in the late 19th century. (Courtesy of Anne and Boyd Hitchner.)

Jehu and Annie Thomas Wood lived in the house at 209 Kings Highway West. In the above picture, they are standing by their gazebo located on the west side of the house with 221 Kings Highway West, the home of Caroline Scull Haines, visible in the background. Below, another Wood family picture taken at the same house many years later shows Marion Nicholson Wood working in the family's victory garden during World War II. The Woods owned and grew crops on the field in the middle of the block surrounded by Kings Highway West, West End Avenue, Euclid Avenue, and Avondale Avenue.

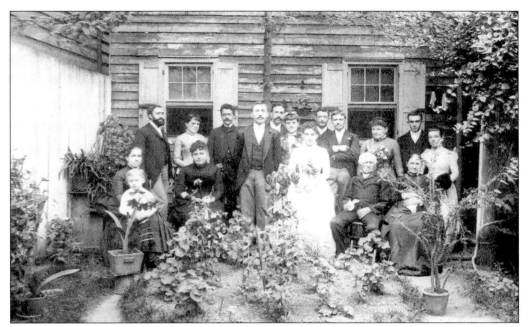

Weddings in the late 1800s were generally simple family affairs like the one seen here. Harry S. White married Ida B. Malsbury on June 25, 1888. The wedding group was photographed in the backyard of the home of Vernona and Walter C. Harris at 204 Kings Highway East. (Courtesy of Don Harris.)

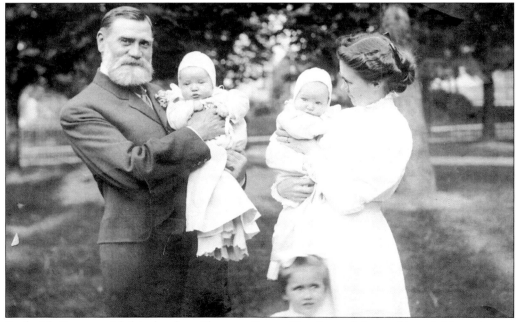

Frederick Sutton, with his daughter Florence Sutton Tomlin and three of her children, is seen in the front yard of his Warwick Road home. Sutton was a successful coffee merchant, bank president, and entrepreneur who died when the *Titanic* sank in 1912. Sutton was returning from a visit with his family in England. (Courtesy of Tom Tomlin.)

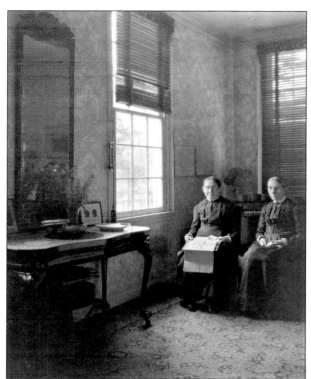

Sarah and Rebecca Nicholson, seen in their parlor with a table and mirror owned by their ancestor Elizabeth Haddon Estaugh, were great benefactors to the community. They were active in the Friends meeting, sewing society, garden club, and others. They also donated the land opposite their home at 65 Haddon Avenue for a public library and historical society building in 1917.

For many years there were large yew trees located on the grounds of the Wood farm at 201 Wood Lane. These trees were a site of historic pilgrimage and honor because they were brought from England and planted by Elizabeth Haddon Estaugh. In this picture, two ladies are enjoying a picnic in the shade of the venerable trees.

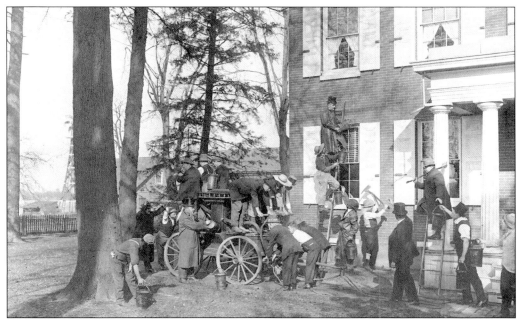

Haddonfield has always had a significant respect for preserving its history. In 1913, a celebration was held to honor the 200th anniversary of the settlement of Haddonfield, using the building of New Haddonfield as the date of the beginning of the town. Vignettes of Haddonfield history were staged on the lawn of the Wood farm at 201 Wood Lane, the site of the original New Haddonfield. The founding of the fire company in 1764 is being portrayed above. As a result of the celebration and the interest that it created, the Historical Society of Haddonfield was established the following year. The picture below was taken at the 75th anniversary of the historical society's founding in 1989. A group of residents who lived in Haddonfield in 1914 when the society was founded were honored guests at the celebration.

INDEX

African Americans, 44, 66, 70, 75
Bancroft School, 69, 76, 77, 91
Belmont Avenue, 67
Birdwood, 2, 8, 58, 82
blacksmiths, 12, 13, 23
Braddock family 28, 29
Capern, William, 66, 79, 94
cemeteries, 7, 46, 59, 61, 115
Centre Street, 11, 49, 56, 78, 87, 102, 106
Chestnut Street, 72, 73, 87, 94, 111
civic association, 8, 33, 57, 103
Clement, Alfred W., 27
Clement, Judge John, 89
Clement Street, 12, 87
Colonial Avenue, 92, 94
Cooper's Creek, 7, 10, 66, 79, 86, 102, 104
Cope, Edward Drinker, 88
Cottage Avenue, 78
DAR, 30, 53
Douglass Avenue, 66, 75
Driscoll, Gov. Alfred E., 82, 95, 113
Ellis Street, 11, 21, 26, 27, 30, 42–44, 60, 66, 83, 90, 104, 113
Estaugh, Elizabeth Haddon, 7, 8, 23, 30, 31, 59, 80, 81, 84, 124
Estaugh, John, 7, 59, 80
Feinstein, Bernard, 34
Feinstein, Isadore, 34, 91
fire company, 8, 45–47, 49, 125
Foulke, William Parker, 2, 8, 82
Friends Avenue, 60, 92
Friends meeting, 7, 8, 42, 46, 59, 60, 84, 86, 92, 124

Friends school, 7, 69, 70
gasoline stations, 22, 34
Gibbs Tavern, 12, 20, 31
Gill, Ephriam T., 105
Gill, John IV, 90, 112
Gill, William H., 112
Glover Avenue, 74
government, 45, 48–52, 54, 55, 84, 88, 90, 100
Greenfield Hall, 83, 90, 91
Grove Street, 10, 20, 21, 57, 62, 86, 99
Haddon Avenue, 12, 19, 22, 29, 46, 48, 54, 55, 60, 67, 70, 81, 82, 84, 85, 87, 92, 99, 110, 113, 124
Haddon, Elizabeth. See Estaugh, Elizabeth Haddon
Haddon, John, 7, 59, 80
Haddon Fortnightly, 53, 57, 102
Haddon Township, 7, 45, 48
Hadrosaurus foulkii 2, 4, 8, 82, 88, 119
Harris, Verona, 123
Harris, Walter C., 123
Harris family 89, 121, 123
Hawthorne Avenue, 58, 99
historic district, 8, 100
Historical Society of Haddonfield, 8, 54, 83, 90, 124, 125
Hopkins Avenue, 68, 99, 112
Hopkins, John Estaugh, 2, 8, 82, 84
Hopkins, Mary Gill, 112
Hopkins, Sarah 80
Hopkins, William Estaugh, 82
Hinchman family, 98
housing development, 8, 74, 79, 81, 94, 98, 99

Indian King Tavern, 8, 13, 52, 53, 83, 91
Kings Court, 26, 89
Kings Highway, 7, 9, 13, 17, 19, 21, 23, 24, 34, 51, 79, 102
Kings Highway East, 12, 22, 26–28, 30–45, 49, 53, 55–57, 59, 61, 62, 64, 65, 68, 73, 83, 86–91, 110, 113, 116, 118, 119, 121, 123
Kings Highway West, 62, 96, 97, 98, 100, 111, 122
Knolltop Lane, 97
Lake Street, 25, 60, 86, 92
Lakeview Avenue, 93
Leidy, Joseph, 2, 4, 8
library, 7, 23, 48, 54, 84, 124
Lincoln Avenue, 57, 66, 71, 73, 75, 87
Linden Avenue, 95
Lippincott, Charles, 76
Lippincott, Joseph Jr., 48
Maple Avenue, 21, 82, 99, 119
Marne Avenue, 99
Masons, 56, 57
Mechanic Street, 12, 20, 30
Mickle House, 83, 90
mills, 23, 24
Moore, Gilbert Henry, 65
Moore, Henry D., 62, 65, 96, 97
Moore, Mary, 65, 97
Moore, Robert T., 97
Moore, William G., 97
Moore family, 97
Moore Lane, 96
movie theater, 23, 44
Mountwell, 7, 78, 79, 87
Mountwell pool, 102, 103
New Haddonfield, 7, 79, 80, 81, 84, 99, 125
Newton Township, 8, 45, 48
Nicholson, Norman, 114
Nicholson, Rebecca, 85, 124
Nicholson, Sarah, 85, 124
parades, 42, 104, 115–118
parking, 20, 37, 49
police, 49–51
ponds, 24, 101, 104, 107
post office, 55
Potter Street, 11, 19, 21, 25, 26, 36, 89, 93
pottery, 25, 92
railroad, 8, 9, 15–19, 23, 37, 71, 72, 79, 87, 117
Redman Avenue, 74, 110
Reilly, Theophilus, 78
Reilly, William, 78
Remington, Clement, 38, 71, 79, 94
Rhoads, Charles, 84, 85
Rhoads, Evan, 10, 120
Rhoads, Samuel Nicholson, 10, 85
Rhoads Avenue, 58
Rhoads family, 84
Roberts Avenue, 83
sports
 summer, 98, 101–105, 108–113
sports
 winter, 14, 101, 106, 107
Stone, I. F., 34, 91
stores
 drug, 23, 28, 30–32, 39
 food, 17, 26, 34, 40–43, 60
 general, 23, 26, 27, 32, 34, 35, 53
Sutton, Frederick, 123
Tanner Street, 19, 22, 32, 35, 44, 54, 85, 86
Tatem, J. Fithian, 74, 108
Tatem, Joseph, 109
Tatem, Mary, 109
Tatem, Robert Moore, 108
taverns, 7, 12, 13, 20, 23, 31, 36, 52, 53, 83, 91
temperance, 36, 52, 84
Trend, Eleanor Reilly, 93
veterans, 58, 73, 114, 115, 117
Walnut Street, 42, 60, 107
Warwick Road, 62, 63, 95, 96, 105, 123
Washington Avenue, 14, 57, 94, 109
West End Avenue, 114
Wood, Annie Thomas, 122
Wood, Ben, 105, 111
Wood, Jehu, 122
Wood, Marion Nicholson, 122
Wood, Robert, 105, 106, 111
Wood, Samuel, 99
Wood family, 120, 122
Wood farm, 74, 80–82, 99, 124, 125
Wood Lane, 67, 80, 99, 124, 125

www.arcadiapublishing.com

Discover books about the town where you grew up, the cities where your friends and families live, the town where your parents met, or even that retirement spot you've been dreaming about. Our Web site provides history lovers with exclusive deals, advanced notification about new titles, e-mail alerts of author events, and much more.

Arcadia Publishing, the leading local history publisher in the United States, is committed to making history accessible and meaningful through publishing books that celebrate and preserve the heritage of America's people and places. Consistent with our mission to preserve history on a local level, this book was printed in South Carolina on American-made paper and manufactured entirely in the United States.

This book carries the accredited Forest Stewardship Council (FSC) label and is printed on 100 percent FSC-certified paper. Products carrying the FSC label are independently certified to assure consumers that they come from forests that are managed to meet the social, economic, and ecological needs of present and future generations.

Mixed Sources
Product group from well-managed forests and other controlled sources

Cert no. SW-COC-001530
www.fsc.org
© 1996 Forest Stewardship Council

Find Your Place in History.